Barbara Catoir

Conversations with Antoni Tàpies

Barbara Catoir

Conversations with
Antoni Tàpies

With an introduction to the artist's work

Prestel

This book is an updated version of the German edition,
Gespräche mit Antoni Tàpies, first published in 1987.

© Prestel-Verlag, Munich, 1991
© of works by Antoni Tàpies, Francis Picabia, Max Ernst and Brassaï: VG Bild-Kunst,
Bonn, 1991

Translated from the German by John Ormrod

Cover: Photograph by F. Català-Roca, Barcelona
Frontispiece: Photograph by H. Spinner, Grasse
Page 68: Photograph by J. Moren

Prestel-Verlag, Mandlstrasse 26, D–8000 Munich 40, Federal Republic of Germany

Distributed in continental Europe by Prestel-Verlag,
Verlegerdienst München GmbH & Co KG,
Gutenbergstrasse 1, D–8031 Gilching,
Federal Republic of Germany

Distributed in the USA by te Neues Publishing Company,
15 East 76th Street, New York, NY 10021, USA

Distributed in Japan by YOHAN-Western Publications Distribution Agency,
14–9 Okubo 3-chome, Shinjuku-ku, J-Tokyo 169

Distributed in the United Kingdom, Ireland and all other countries by Thames & Hudson
Limited, 30–40 Bloomsbury Street, London WC 1B 3 QP, England

Series cover design: KMS-TEAM

Offset lithography by Karl Dörfel Reproduktionsges. mbH, Munich
Typeset and printed by Buch- und Offsetdruckerei Wagner GmbH, Nördlingen
Bound by Conzella GmbH, Pfarrkirchen

Printed in the Federal Republic of Germany

ISBN 3-7913-0831-9 (German edition)
ISBN 3-7913-1149-2 (English edition)

CONTENTS

Foreword

Charles Baudelaire spoke of the 'universal religion' that was the exclusive preserve of the 'alchemist of thought'. Tàpies is just such an alchemist. He has a penchant for the hermetic, the mystical, the cryptic, for puzzles and enigmas which resist any attempt to decipher them in simple terms. An artist like Tàpies, whose work is full of arcane signs, is unlikely to aim for absolute clarity in his statements on art. One could hardly expect him to reveal in conversation all the secrets buried in his pictures and sculptures.

This book deals with the hermetic, labyrinthine world of Tàpies, which begins with the architecture of his house in Barcelona and manifests itself most clearly in his fondness for obscure symbols and in his love of books, which he regards as his most powerful allies. This mysterious world is an enclosed, self-sufficient cosmos. Although my conversations with Tàpies took place over a period of several years, I have decided to disregard chronological order and arrange the material thematically, in a way which follows the system of the artist's thinking. His responses to my questions are governed by the principles which also shape his art: his answers are labyrinthine and ambiguous, illuminating aspects of his work and then promptly shrouding them once more in obscurity. Hence, the conversations with Tàpies are more like a game than a confession, a game of ideas and associations in which the artist sometimes lays his cards on the table and sometimes conceals his hand.

As in his work, which continually revolves around the same set of themes and motifs, recurring over and over again in paintings, drawings and prints, assemblages, clay sculptures and stage sets, Tàpies always steers the conversation along paths of his own choosing. Here, too, he pursues a deliberate strategy, often involving the interviewer in an elaborate game of hide-and-seek. The introductory essay attempts to uncover some of the secrets which Tàpies was unwilling to reveal in conversation. It provides a key to a new understanding of Tàpies's art, in which both Western and Eastern forms of mysticism play a crucial part. His work is also influenced by alchemy, the Cabbala and other magical games. This is the world in which Tàpies lives: it reveals itself in the books and numerous small objects with which he surrounds himself and which act as a stimulant to his imagination. These sources of inspiration range from Ramon Llull's *Ars magna* to the Tarot cards of which Tàpies makes use, combining puns with cryptic associations, in his *Cartes per a la Teresa*. The Tarot, a method of fortune-telling based on a human prophetic gift, is a repository of ancient wisdom. The same can be said of Tàpies's art. BARBARA CATOIR

In the Labyrinth of Signs

The dialogue with Antoni Tàpies published here is the product of several interviews, conducted in French, which took place at intervals over a number of years. It began with my first visit to the artist's home in Barcelona, in the summer of 1974. We recorded our conversation on tape. The dialogue continued in correspondence and in several subsequent interviews. The final conversations in this book took place over five consecutive days in January 1987.

Tàpies uses language in a manner which combines passion and immediacy with caution, even wariness. He approaches words with great care and strives to avoid narrowing down their meanings. Thus, his favourite expressions are words such as 'suggérer' and 'évoquer': inspiring, conjuring up, suggesting, evoking. His aim is to let words themselves bring the world of objects to light, gradually, the word itself almost becoming an image. Much of what he discloses in conversation is based on an inner vision, a set of insights and ideas informed by Christian mysticism and Eastern philosophy, which have a number of important things in common.

His often hesitant manner of expression, hedged about with qualifications and wary of fixed concepts, lends his ideas a complex linguistic colouring which poses considerable problems for the translator. It corresponds to his unorthodox cast of mind, to his insistence on the need to shake people's confidence in what they think they believe and to remind them of the infinite number of things still waiting to be discovered.[1] The direction which our conversations took was governed by Tàpies's unconventional thinking, which is always open to new ideas, and by his continual willingness to pursue the dialogue a step further or to revise the ideas which he had already formulated on a given topic.

There were moments when I felt as though I were talking to a missionary, uttering pronouncements such as: 'Many wise men have taught us that happiness is to be found in knowledge and love.' But then the childlike side of Tàpies's nature would re-emerge, as he spoke in purely emotional terms of music that he liked – of a concerto, for example, which consists of a single note – or as he described one of his early stage sets, an absurd scene with black tail-coats which were suddenly whisked up into the flies. At such moments, the artist becomes a mimic: with laughter in his wide-open eyes, he employs wild gesticulations and assorted whistling and humming noises to create a vivid visual and acoustic re-enactment of a situation.

This is Tàpies in the role of magician and conjurer. In other respects he is cautious, even timid: he says, for example, that he would never

work under the influence of drugs and is frightened of them.[2] Then there is Tàpies the thinker, subjecting each concept to careful scrutiny. Finally, there is the artist-philosopher, extracting ideas which he finds important from a wide variety of teachings: Taoism, Buddhism, Zen, Oriental and Western mysticism, and Existentialist philosophy.

THE SETTING

Our conversations were all held in the same place: the Tàpies family home, built to the artist's designs in the early 1960s, at 57 Carrer Saragossa in Barcelona (see fig. 1). With its narrow façade, the house resembles a tower. From the street, all one sees is an apparently window-less wall: the window openings are masked by fixed, visor-like shutters. Wedged in between the adjoining buildings, the house has an air of anonymity and aloofness. There is no nameplate by the doorbell, nor indeed is there a proper front door. One enters the house through a wicket-gate set into the wooden garage door that extends along the whole breadth of the ground floor. When one rings the bell, the gate opens only the merest crack, rather mysteriously, until the concierge has satisfied herself of the visitor's bona fides. On each of my visits the garage, which is shrouded in semi-darkness, has always contained the same large, light-coloured Mercedes, a collector's item that is surely the only one of its kind in Barcelona. Stacked up against the walls there are wrapped-up pictures. A plain wooden staircase leads up into the main part of the house.

We invariably met in the room on the first floor. I settled on the small twin sofa, and Antoni sat opposite me on one of the old Chinese wicker armchairs by the stove, which hangs down like a long pipe in front of the big glass wall. My gaze was always directed towards the open side of the room, which gives out on to an enclosed terrace with a group of tall palm-trees, protected from the sun and rain by overhead blinds and shades made of a material that filters out the light. The terrace is a piece of artificial nature, a kind of hothouse, which creates a muted, dreamlike atmosphere. Tàpies sat facing away from the window: his gaze fell on the shadowy interior of the dark room, with its walls of bare, brown brick. The room is like a gallery, filled with pictures and *objets d'art* of widely varying provenance, all of which have their own fixed place. High up on one of the walls, for example, there is an outsized shoe. Tàpies tells me that it came from a shoemaker's window display: he has left it just as he found it, like the *objets trouvés* of the Dadaists.

Regardless of whether our choice of position was deliberate or uncon-scious, the way that we always faced in opposite directions is in itself revealing. It was only after we had got to know each other well that I

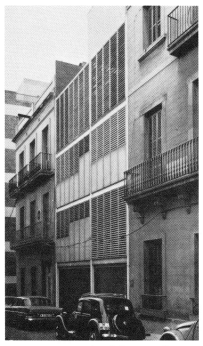
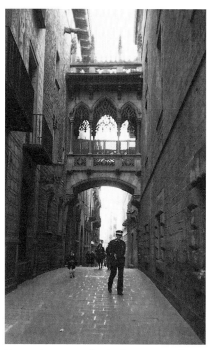

Fig. 1 The Tàpies family home in Carrer Saragossa, Barcelona

Fig. 2 A street in the Gothic quarter of Barcelona

realized the significance of this seemingly trivial detail, which echoed through our conversations and corresponded to Tàpies's view of art, reflecting his interest in darkness and hermetic obscurity. In his early oil paintings, such as *The Sorrow of Brunhilde*, *The Last Reader: The Letter* and *The Legerdemain of Wotan* (fig. 3), his gaze is already focused on the interior, on furnishings and other objects. Even in the paintings with heavy, roughly textured impasto surfaces, whose scratch marks and spray-can drawings conjure up associations of street walls, Tàpies's attention is directed towards the idea of closure and confinement. The images evoke the narrow, dark streets in the Gothic quarter of Barcelona (see fig. 2), where the rows of tall houses are linked by overhead corridors and the walls and gates are like palimpsests, with the traces of the present superimposed on those of the past: the traces of blood and fire from public executions during the Middle Ages, the bullet-holes from the Spanish Civil War, the fasces emblem of the Falange, daubed over by the opposition, and the spray-can graffiti of our own time. These are streets like tombs or dungeons, hermetically sealed off from the world outside.

Carrer Saragossa lies at the northern edge of what is now the business and shopping centre of Barcelona, where the spacious elegance and the extravagant Art Nouveau façades of the *Eixample*, laid out in squares in the second half of the nineteenth century, give way to cramped, crooked

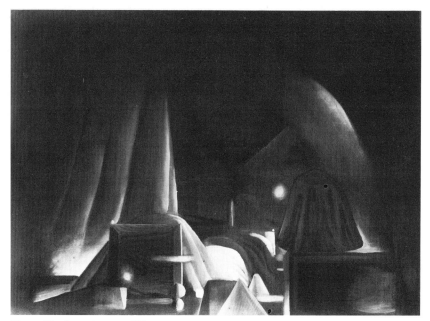

Fig. 3 *The Legerdemain of Wotan*, 1950

streets which wind up and down steep hills. Not far from Carrer Saragossa, a narrow one-way street, one enters Carrer Balmes, a wide, busy road which leads up to the Tibidabo, a hill which stands some 1,600 feet high in the north of the city and is crowned by a massive, heavy statue of Christ looking down at the ever-vibrant, noisy metropolis below. Tàpies used to live in Carrer Balmes before he and his family moved into the newly built house. His mother lived there, and one of his sons still lives nearby. This kind of attachment to a city, or even to a specific neighbourhood in which one's family has been established for several generations, is typical of Spain, where ties of kinship, too, are close. The Tàpies family is no exception: it is a tightly knit clan which invariably sends a delegation to his exhibition openings.

Over the years I penetrated into one room after another in the narrow, labyrinthine house. The first room I saw was Tàpies's studio (fig. 104), which is on the ground floor at the back of the house and can be entered only through the garage or via a steep staircase leading down directly from the terrace. Seen from the top of the staircase, the studio itself appears like a Tàpies picture. The painting materials, the sand, the marble-dust, the old cloths, the cords and paintpots, the miscellaneous objects, such as the big baking sieve: all these things prepare the eye for the picture which will eventually emerge from them. Later Tàpies showed me his library, with its collection of old and precious books, and several other small rooms in which he lives, works and stores his archives. However, I never saw a kitchen or anything of that kind. As in a Japanese

house, the family's private living quarters remained invisible. We sat and talked in an atmosphere from which everyday activities were rigorously excluded. The bustle of the family and the household seemed banished into the far corners of the house. During our conversations we shut ourselves off from the outside world: the atmosphere was intellectually intense and, whenever our concentration lapsed and we began to drift off the subject, Tàpies would remind me that we were supposed to be 'working'. The mood was very different from that which prevailed outside these 'séances', at our meetings in Paris, Zurich, Amsterdam, Brussels and Venice, or even in Barcelona, when I joined Tàpies and his family or friends to go out for a meal or to visit an exhibition.

None of the rooms that I know has an outside view. The shutters allow only a minimal amount of light to enter, falling at a sharp angle. This is far from unusual in Spanish houses, where the shutters often remain closed day and night in order to keep out the sun, the oppressive heat and the noise. Yet in this modern house the exclusion of sunlight helps to create an air of mystery which has a disorientating effect. The overall impression is one of artificiality, albeit not of the luxurious, theatrical kind that one finds in the novels of Huysmans: Tàpies is no Des Esseintes. Nevertheless, the interior has been designed with infinite care, right down to the last detail, as an environment which is at once a protective shell, a living space and a work of art.

Apart from the studio, where Tàpies generally works in the morning, the most hermetic room in the house is the library. Here, the artist spends the afternoons reading and listening to music. It is a dark, book-lined room, sealed off from the outside world: the only source of daylight is a narrow aperture almost at ceiling height. Among the old books – contemporary literature on art, works of reference and catalogues are kept in another room – one sees numerous Eastern *objets d'art*, including books from the Orient which have acquired the status of pure objects because their content remains inaccessible. There is a low Chinese lacquered table, a large Khmer sculpture – the torso of a goddess – and a picture on a scroll, painted in an Oriental manner by Tàpies, using broad, black brushstrokes on a dark-brown ground. These things lend the room a mystical, sacred quality. At the far end of the library, shrouded in gloom, there hangs a small, dark painting by Zurbarán, one of his numerous depictions of martyrs, showing a monk with a knife stuck in his neck. Tàpies is particularly fond of this picture. We have often looked at it together. It has a hidden significance for him, connected with his temperament, upbringing and background. His outlook was shaped by Spanish Catholicism, which pervaded the atmosphere in which he grew up: Barcelona is a Catholic city, his parents were Catholics and, as a small boy, he even attended a convent school. Subsequently, he broke with the Church and with orthodox forms of Christian belief – but not with mysticism.

It is far from coincidental that, immediately adjacent to the image of the martyr, one finds a set of books on Spanish mysticism, which, like all forms of mysticism, has pantheistic leanings: the Church continually suspected its exponents of being heretics. The ecclesiastical hierarchy felt seriously threatened by the teachings of the mystics, who sought to circumvent institutional forms of belief and find a direct, personal form of access to God, whom they no longer regarded as a supreme authority standing above the world and ruling it from outside, but as an inner force which revealed itself through contemplation. This, however, does not entail subjectivism, for the self strives to overcome the personal and the individual in order to be subsumed in the absolute. The Church saw meditation as particularly dangerous because it not only unleashed a new and powerful psychic potential, but also constituted a form of spiritual and philosophical training which made a decisive contribution to the liberation of the individual.

RAMON LLULL OR THE ART OF COMBINATION

Tàpies is particularly interested in the mystical teachings and the philosophy of Ramon Llull (1232–1315/16). He owns a collection of illuminated editions of Llull's writings, published in the fifteenth and sixteenth centuries. Llull (also known as Raymond Lully) was a universal genius: a theologian and philosopher, a poet, missionary and scientist, a *doctor illuminatus* who is venerated by the people of Catalonia as a kind of patron saint. Through his philosophical treatises and his epic and lyric poems, most of which were written in Catalan, he helped to elevate Catalan to the status of a literary language.

The Surrealists, too, were interested in Llull's universal philosophy and mysticism, from which one of the major currents in Spanish philosophy derives: he was the founder of a tradition of thought which later influenced Athanasius Kircher and Gottfried Wilhelm Leibniz. André Breton mentions Llull in his manifestos of Surrealism. What fascinated the Surrealists, and subsequently Tàpies, whose early work was inspired by Surrealism, was the way in which the philosopher created connections between widely differing areas of knowledge, practising what he himself called the 'art of combination'. Llull not only employed the *ars combinandi* in the pursuit of philosophical and scientific truth, he also put it to artistic use in his poetry, which is based on the same mechanisms of inspiration. The Llull scholar Erhard-Wolfram Platzeck has shown that Llull's aphorisms and *proverbia* rely entirely on the device of combination.[3] Breton's comparison of inspiration with a 'spark', a 'phenomenon of light' connecting two disparate realities through the art of combination, can be seen as an explanation of the mystical revelation of unity –

an experience described in the teachings of Christian mystics as a sudden illumination of the soul, comparable with the 'sirr' of Islamic mysticism.[4]

Both Tàpies's work and his statements on art contain numerous references to the writings of Llull. He describes painting as a way of thinking about life, and, in his view, the capacity for meditation is a prerequisite of artistic existence. It is also essential to the reception of art: the viewer requires a similar faculty and must be able to activate it at will. As Tàpies says: 'The meaning of a work depends on the co-operation of the viewer. Those people who live without inner images, lacking imagination and the necessary sensitivity to generate their own set of mental associations, will see nothing at all.'[5]

Similar ideas can be found in the writings of Llull, who says that the process of forming judgments depends on the attitude of the knowing subject: his 'inner forces of the soul' have to be focused in the right direction. In Llull's theory of knowledge 'the object of knowledge is integrated into the cognitive relationship formed by the correlation between the knower, the knowable and the act of knowing. Unless the knower puts himself in the right frame of mind to perceive the knowable fully and properly, how can an act of apperception take place?'[6]

It can safely be assumed that Tàpies, who devotes so much thought to the creative process, has delved a great deal further into Llull's philosophy than he is prepared to admit in conversation. He draws a veil over the question of his sympathies for Llull, which, time and again, link his work with that of the philosopher. The extent to which the large letters and the combinations of letters and numbers in his work derive immediately from Llull's *ars combinandi* is a matter for speculation. Yet there can be no doubt that the ideas of Llull have provided an important source of inspiration for Tàpies's hermetic art. Llull devised an alphabet of his own, in which the letters stand for concepts which, by means of diagrams, figures and systems of signs, can be combined in such a wide variety of different ways that their meaning oscillates.[7] The letters in Tàpies's pictures are similarly ambiguous, admitting of numerous different interpretations. Llull regarded his 'meaningful figures', created with letters, as a legitimate aid to the mind in producing an image of 'spiritual figures'.[8] In the work of Tàpies the abstract sign is, in addition, a means of breaking the mimetic character of the pictorial image through the introduction of abstract thought. This triggers off a dialectical process: the sign both opens itself up to associative thinking and locks itself away in a maze of ambiguity.

In his *Ars maior*, for example, Llull constructs six geometric figures, designated by the letters A, S, T, V, X and Y-Z, which can be combined into a further series of figures (fig. 4). A is the figure of the 'basic dignities', s denotes the relationships between the object and true knowledge, and T stands for the principles governing distinctions of meaning.

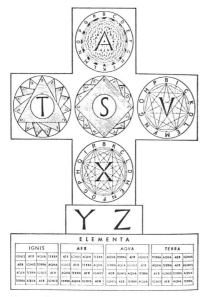

ELEMENTA

IGNIS				AER				AQVA				TERRA			
IGNIS	AER	AQVA	TERRA	AER	IGNIS	AQVA	TERRA	AQVA	TERRA	AER	IGNIS	TERRA	AQVA	AER	IGNIS
AER	IGNIS	TERRA	AQVA	IGNIS	AER	TERRA	AQVA	IGNIS	AER	TERRA	AQVA	AER	IGNIS	TERRA	AQVA
AQVA	TERRA	IGNIS	AER	AQVA	TERRA	AER	IGNIS	AER	IGNIS	TERRA	AQVA	AER	IGNIS	TERRA	AQVA
TERRA	AQVA	AER	IGNIS	TERRA	AQVA	IGNIS	AER	IGNIS	AER	TERRA	AQVA	IGNIS	AER	AQVA	TERRA

Fig. 4 Diagram in Ramon Llull, *Ars maior*

Fig. 5 Diagram in Ramon Llull, *Ars inventiva*

Certain works by Tàpies contain obvious references to the various combination tables found in either the *Ars maior* or the *Ars inventiva*.

The letters which appear most commonly in Tàpies's work are A, T, V, X, S, R and M. Some of his pictures consist only of a single capital letter: this is the case, for example, with the 'M' compositions which he has done at various times and in several different techniques. In 1960 he painted a capital M in ochre colour with an earthy texture on a dark ground. This was followed in the early 1980s by the variations *M and Sign* (1982) and *White M* (1984). One of the ten lithographs in *Berlin Suite*, a series

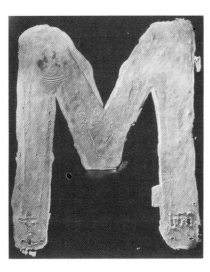

◁ Fig. 6 *M*, 1960

Fig. 7 *Black Rhombus*, 1973

16

dating from 1974, also contains a large letter M, with a T behind it in the centre.

In Llull's *Ars maior* the capital letter M stands for the will, which is mobilized in the service of the qualities denoted by the letters A, T, V and X. Looking at Tàpies's 'M' picture of 1960 (fig. 6), one sees, in the centre, the letter V, the figure of decision between vice and virtue; at the bottom left and right respectively there is a T and an X, which are signs of opposition; the four vertical scratches in the bottom right-hand corner allude to the vertical stripes on the Catalan flag. The correspondence between the picture and Llull's system of combinations is anything but coincidental. The lithograph from the *Berlin Suite* can be interpreted in the same way.

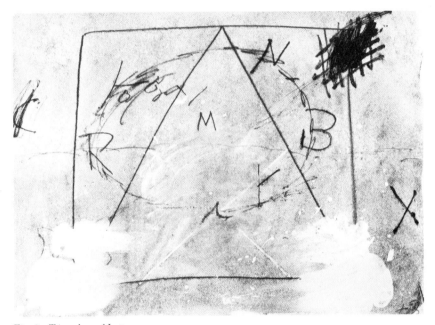

Fig. 8 *Triangle and Letters*, 1973

In other works one finds direct references to the tables of figures devised by Llull. One thinks, for example, of *Black Rhombus* (fig. 7) or the drawing *Triangle and Letters* (fig. 8), both dating from 1973. Following the letter V in Llull's *Ars maior*, the letters B, C and D stand respectively for faith, hope and charity. Together with the letter A, which denotes the basic principles, these are the letters in Tàpies's lozenge figure, which corresponds to one of the six geometric figures in the *Ars maior*.

It is equally plain that the letters A and T, which also combine Tàpies's initials with the name of his wife, Teresa, refer to the two main figures of the *Ars inventiva* (fig. 5). On a number of occasions Tàpies has used these letters in such a way that they constitute a kind of illustration, both picture and object, which re-enacts the message of the book. The tab-

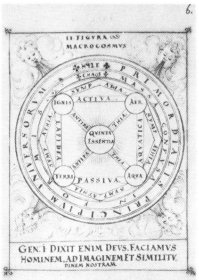

leau-cum-object entitled *Composition* (plate VI) which he made in 1977/
78 (as in all his pictures since 1954, the title gives no indication of
content, leaving the viewer to guess at the meaning of the work), incor-
porates the leather binding of an old book, on to which strips of paper
have been glued to form the letters A and T. A variation on the same
theme is to be found in the clay sculpture *Large Book* of 1986, a huge,
heavy work with an exceptionally hermetic character, which puts one in
mind of Llull's *Ars magna*, the treatise that forms the cornerstone of the
philosopher's writings.

Fig. 11 *Books*, 1985/86

18

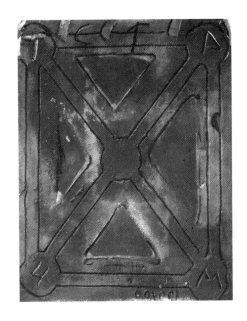

◁ ◁ Fig. 9 *Diana*, 1973

◁ Fig. 10 Page from Cornelius Petraeus,
　　　　　Sylva philosophorum,
　　　　　a seventeenth-century
　　　　　Hermetic manuscript

Fig. 12 *In the Form of an X,
　　　　Brown and Grey*, 1972

　　The name Llull itself appears in a number of Tàpies's paintings, draw-
ings and prints. On occasions, the double Ls mean that the name is
recognizable only as a barely legible gestural squiggle, and sometimes
only the letters R and L remain as an allusion to the poet and philosopher.
This is the case in the coloured aquatint *Three Rs* (fig. 13), whose title
refers to three medieval theologians – Ramon Llull, Ramon Penyafort
and Ramon Sibiuda – whom Tàpies reveres as inspired madmen: this
undoubtedly accounts for the inclusion of the word 'foll' in the top right-
hand corner.

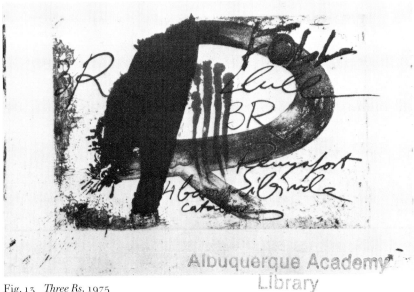

Fig. 13 *Three Rs*, 1975

Fig. 14 *Painting with White Ribbon*, 1974

In a number of other works the name Llull is juxtaposed with the bloodstained image of the Catalan flag or partly concealed by it, as in the *Suite Catalana*, a set of five aquatints created in 1972. The personality of Ramon Llull informs Tàpies's entire oeuvre, from its very beginnings to the present day. At the end of 1986 a selection of Llull's texts was published with etchings by Tàpies, a project on which the artist had worked for over ten years.[9]

DAU AL SET – SEVEN ON THE DIE

It is interesting to note that Ramon Llull was highly regarded by the artists of the *Dau al Set* group, who placed him on a par with Jacob Böhme, Antoni Gaudí and Max Ernst. This was fully in keeping with the Surrealist spirit which guided *Dau al Set*, a small-circulation arts review founded by seven young artists in Barcelona in 1948. Tàpies was one of its founding contributors, and he published numerous drawings in the magazine during the first two years of its existence. Its magical name was devised by the Catalan poet and artist, Joan Brossa. With a format resembling that of a loose-leaf school exercise book, it appeared at irregular intervals, and the members of the group took it in turn to act as editor. Apart from drawings, the magazine contained nothing but scraps of ideas in the form of quotations and names; the texts often consisted of only a few sentences. However, the list of names put forward for debate by the various members of the heterogeneous group is interesting and important in view of Tàpies's subsequent artistic development. The contributors had complete freedom to indulge their personal preferences. For example, the March/April issue in 1949 was edited by Modest Cuix-

art, who provided Tàpies with an opportunity to present his work to the public. The artist combined his drawings with a text by Enrique Villena, a fifteenth-century Spanish mystic (see fig. 15). This represents a continuation of the Surrealist method of finding striking analogies, which is typical of *Dau al Set* as a whole.

The May issue of the same year was dedicated to Georges Méliès. It consisted of a double-page spread plus a single loose-leaf page with a few comments about Joan Miró by Brossa. A special Paul Klee issue was published in June 1950 to mark the tenth anniversary of the artist's death; it also contained a short text in French on Jean-Paul Sartre. A further issue was devoted to the giant dolls of Berga, a set of mythical figures which traditionally feature in festive processions; pictures of them are also to be found in illustrated broadsheets, and they serve as a model for children's cut-out figures.

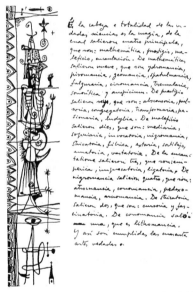

Fig. 15 Pages from *Dau al Set*, March/April 1949

The wide range of topics dealt with in the magazine is directly related to Tàpies's personal interests and inclinations. In our conversations the same subjects cropped up again and again: Llull, Gaudí, Miró, Klee and Méliès, the Cabbala, magic and the art of the conjurer. Tàpies explained that, initially, the magazine was dominated by Brossa and by Surrealism in general. 'We were also greatly influenced by Brossa's ideas on conjuring and the art of illusion. Brossa himself belongs to the world of the theatre; he writes plays. Perhaps there was some kind of connection between all these things.'[10]

The spirit of Surrealism also guided Brossa's hand in writing the text to accompany Tàpies's first one-man exhibition, held in 1950 at the Laietanes gallery in Barcelona. Written in the form of an oracle, it was published in the October/November 1950 issue of *Dau al Set*, which also served as a catalogue to the exhibition, a practice which was repeated on a later occasion. The catalogue contained a complete list of the fifty-four paintings in the exhibition, followed by Brossa's enigmatic comments on Tàpies. Five pages long and printed on grey paper, the text has to be read in poetic terms. At the top of the first page stands the world 'ORACLE' in

Fig. 16 *Letters* (or *Playing Cards*) *for Teresa*, 1974

red capital letters, and the first paragraph begins with what sounds like the account of a dream: 'On the 13th day of the ninth month of the year 1949, I, Joan Brossa i Saganta, was resting in my chambers and heard a voice which said: Joan Brossa! Cast the fortune of Antoni Tàpies! Cast his fortune, Joan Brossa! And to him, Antoni Tàpies, you shall make this message known!' A drawing which Tàpies did in 1950, depicting the lines in a palm (fig. 18), also appears to be concerned with the subject of clairvoyance.

The dramatic way in which Brossa sets himself up as a prophet, pur- porting to read the future of a young painter-friend whose career was still in its infancy, exemplifies the magical power which Brossa successfully strove to wield within the group. It also points to the influence of Surreal- ism, which dominated the ideas of these young artists despite the re- moteness of Barcelona from Paris. Breton had spoken of the significance of the oracle in his manifestos of Surrealism. The spirit of Surrealism is also apparent in the illustration – a self-portrait with the attributes of a winged mythical beast – which Tàpies did for the cover of the magazine.

The last issue before the group broke up appeared in October 1951 (following which the magazine continued publication for a while under the editorship of J. J. Tharrat). Once again, the subject was an exhibition, this time of works by all members of the *Dau al Set* circle. The modest show was held at the Sala Caralt in Barcelona. Tàpies designed the cover, and the text was written by Michel Tapié.

The years 1949 and 1950 are the most significant in Tàpies's work as a contributor to *Dau al Set*. He designed several covers for the magazine, including one for the December 1949 issue on which he co-operated

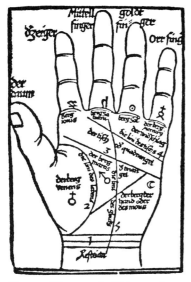

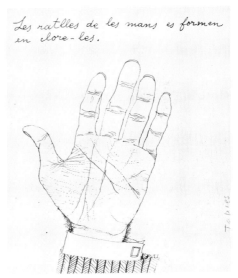

Fig. 17 Diagram of a Chiromantic hand, in B. Coclès, *Physiognomania*, Strasbourg, 1551

Fig. 18 *The Lines of the Hand*, 1950

with two other artists: the central section, illustrating the title, was by Modest Cuixart, the bottom section was by Joan Ponç, and Tàpies did the drawing at the top. Round about this time the group produced a joint issue of the magazine with the poet Josep Vicens Foix, who had done a great deal to stimulate the thinking of the young artists. Foix, who by then was in his late fifties, was a former contributor to the Surrealist magazine *Monitor* and played a major part in disseminating the ideas of Surrealism.

The pictorial world seen in Tàpies's early work – for example, in the drawings which he did for *Dau al Set* – is a world of dream. This determined the direction of his artistic development over the first ten years of his career, until 1954. For centuries, the dream, *el sueño*, has loomed large in Spanish literature and art. Dreams are the phantom images of life in the tower of Segismondo, the hero of Calderón's *La vida es sueño*;

they fulfil the wishes of Don Quixote, the heroic fool; they provide the inspiration for Goya's monstrous figures and for Picasso's series of satirical etchings entitled *The Dream and the Lie of Franco*. In the work of the young Tàpies the thematic importance of this alternative, nocturnal reality can be gauged from such titles as *Dream Garden* and *Nocturne*.

Breton called Spain 'une terre surréaliste', not only on account of the number of Surrealist artists it produced, but also because the very soil of the country, protected on three sides by the sea and to the north by the Pyrenees, is surrealistic. Spain was shaped by the contrast between the breadth and the narrowness of its horizons, between the pioneering spirit of the conquistadors and the insular mentality which sealed the country off from the concerns of other nations. This latter aspect of the Spanish character has more to do with the powerful influence of the Catholic Church than with the country's geographical situation. The sense of unity which enabled the Spaniards to defend themselves against the Arabs became a solid cordon, holding the nation together and ensuring the survival of its traditions. The eventual result, however, was cultural paralysis and authoritarian gloom. This, in turn, bred various forms of irrationalism, which offered a means of escape from the prevailing atmosphere of austerity. The road to freedom lay in the emphasis on the visionary, the absurd, the obsessive and the arcane, in the realm of dream and poetic legend.

The images of black gold and the petrified tears of Saint Teresa of Avila are typical of Spain, a country of conquerors, mystics and dreamers. Breton's dictum points to a Surrealist reality which formed the basis for the irrationalist architecture of Gaudí, the rebellious, anti-clerical films of Buñuel, the hallucinations of Dalí, the visual poetry of Miró and the crepuscular mysticism of Tàpies.

THE EARLY WORK

To the intellectuals of Barcelona in the years immediately following the end of the Second World War, Surrealism was almost a kind of secret society. Books and magazines were hard to come by. The young generation of which Tàpies was a member relied wholly on the stories and documents of those who had witnessed the beginnings of the Surrealist movement at first hand in the 1920s and early 1930s. Thus, the poet Josep Vicens Foix and the art collector Joan Prats became crucial figures, mediating between the generations. It was Prats who introduced Tàpies to Miró in 1948. Although he was barely twenty-five at the time, Tàpies immediately sensed that the encounter with Miró, who was thirty years his senior, was an event which would have a major significance for his own development.

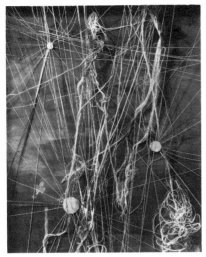

Fig. 19 *Box of Strings*, 1946 Fig. 20 *Grattage on Cardboard*, 1949

However, in these early years Miró was by no means the only figure who attracted Tàpies's interest. At the beginning of his career he was open to all kinds of influences, tirelessly exploring one style after another. He experimented with a wide range of different, even conflicting, means of artistic expression and stylistic devices. In the mid-1940s he began to make abstract collages, using such discarded commonplace materials as bits of cord and thread, and torn, crumpled tissue paper or newspaper (see fig. 19). These pictures represent an attempt to come to terms with the heritage of Dada and the work of, among others, Francis Picabia. At the same time as he was working on the collages Tàpies painted a set of pictures of human figures reduced to mere ciphers, in a style resembling that of *art brut*. Here, for the first time, he adopted a mixed-media approach, mixing marble-dust into the paint, gluing rice on to the painting and drawing over it in charcoal and crayon (see fig. 20). He even employed the technique of *graffage*, roughening, slashing and perforating the material – at this time generally paper or cardboard – of his pictures. Yet all the while he was also producing both realistic portraits (see fig. 21, 72) and pen-and-ink drawings in the two-dimensional, linear style of Matisse (see fig. 71). To these different modes was added, from 1947 onwards, a series of Surrealist pen-and-ink and charcoal drawings using figurative motifs. The drawings owe part of their inspiration to the 'poetic' strand in the work of Miró and Klee (and of Garcia Lorca, who in the mid-1920s endeavoured to translate poetry into drawing), but they are also influenced by the visionary landscapes of Ernst and the anecdotal fantasies of Dalí. One is astonished to find Tàpies persisting in this eclecticism for fully ten years, until 1954. By the time that his search for a personal style ended, he was over thirty.

Fig. 21 *Portrait*, 1946

In the early collages Tàpies already shows a highly developed feeling for materials, and one sees the beginnings of the raw, simple language, situated on the boundary between speech and silence, from which his individual style evolved. Compared with these works, the figurative pictures – dream labyrinths loaded with symbolism and evincing a certain *horror vacui* – appear garrulously anecdotal (see plate 1 and fig. 59). These images, stylistically heterogeneous and mannerist in tendency, are also interesting in terms of their iconography. Tàpies addresses the themes of the artist as sufferer and visionary, and the powerful influence of Spanish Catholicism, whose dogmas had governed his own upbringing. Among the recurring motifs are the cross, the chalice, the *soutane*, the monstrance, and the cowls of Capuchin monks. Tàpies also uses these motifs in a number of early self-portraits in which he depicts himself in the guise of a priest or a magician (see fig. 22).

Fascinated as he was by magic and mysticism, Tàpies repeatedly portrayed himself as possessing magical powers, notably in (*Mystical*) *Self-Portrait* of 1947 (fig. 23). Here, the lines of the artist's spiritual cosmos are seen as emanating from the eyes, with the exception of the broken line which forms an aureole around the head. Together with the hands, the eyes are the painter's most important sense organs. The position of the hands and the perspective also indicate an interest in magical phenomena and esoteric doctrines. Tàpies often depicts himself as if seen from above, with the self in the picture looking up at the second self of the artist and viewer. In these drawings we find the artist scrutinizing and questioning himself, exploring his own unconscious. This quest has continued right up to the present, but it has since assumed different

forms. When asked to name the most important maxim governing his life, Tàpies replied that his principal aim was the achievement of self-knowledge. Thus, his search for a personal means of artistic expression harmonized with an interior monologue in which he grappled with psychological and religious problems and, later, with philosophical questions.

Tàpies also addresses the subject of religion in some of his early collages. In 1946/47 he painted a small-format watercolour with a cross made of newspaper (fig. 25). The edges of the cross are partly torn by hand and partly cut with scissors; its vertical axis is slightly off-centre, and it appears to float above the dark background, which looks as though it were blackened by soot.

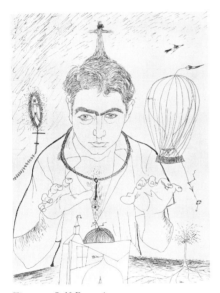

Fig. 22 *Self-Portrait*, 1947

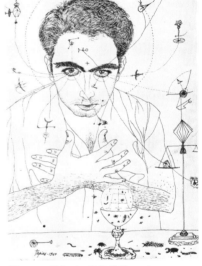

Fig. 23 *(Mystical) Self-Portrait*, 1947

The cross is an ancient symbol of human orientation: before it was adopted by Christianity, it was part of the mythical geography which linked each of the cardinal points of the compass with a particular set of legends. In the work of Tàpies it takes on an ambivalent symbolic significance. The outward form of the cross in this work, and of the Saint Andrew cross, which is also a recurrent motif in Tàpies's pictures, refers to the original, ancient symbol that is also the foundation of Christian iconography. Yet its inner structure is modern, speaking of contemporary religious dogmatism: the form of the Greek cross has been cut out of the obituary columns of a Church gazette. To the left of each of the obituary notices there is a Latin cross, above which the name of the deceased is set in bold type, followed by a trite little memorial poem.

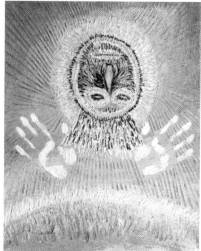

Fig. 24 *Zoom*, 1946

Fig. 25 *Newsprint Cross*, 1946/47

It was the ordered typography of the obituary column which appealed to Tàpies, and in his later paintings that incorporated newspaper clippings he often used similar cuttings from the small ads or the lists of share prices in the business section. In this collage the typography augments the composition by adding a further set of co-ordinates. Set on the diagonal, the obituary notices with their crosses contrast with the vertical and horizontal lines of the main cross. A further direction of movement is indicated by the scraps of tissue paper, which rise towards the top edge of the picture as if impelled by the heat of the fire that is clearly smouldering in the blue-black background. The seemingly random manner in which the pieces of paper are arranged is, in fact, the product of formal calculation. Tàpies establishes a dominant form by placing the triangular piece of paper in such a way that the top end of the triangle appears to be an extension of the vertical beam of the cross. By cutting one edge of the paper with scissors and tearing the others, he creates a further set of lines, like rays of light that continue beyond the borders of the picture. This, too, is one of the enduring features of Tàpies's work. The idea of resurrection immediately springs to mind, but one must remember that for Tàpies, as for Baudelaire, religion is universal, created for the 'alchemist of thought'.

The same year, shortly after he created this mystical image, Tàpies produced a variant entitled *Collage of the Crosses*, which he exhibited at the first Salon d'Octubre in Barcelona in 1948. The work aroused the suspicion of the clergy because, as Tàpies recalls, somebody had noticed that the tissue paper used in the collage was actually toilet paper. The Bishop of Barcelona sent an emissary to the exhibition to determine whether the picture was blasphemous or insulting to the Church.

The suspicion was not entirely unfounded, as Tàpies had left the Church several years previously, while retaining his interest in mysticism as a negative theology. From this point onwards, his brother in spirit was Valéry's Monsieur Teste, who, convinced that the seeker must inevitably encounter darkness, wrote in his 'logbook': 'Give us, o darkness, give us the highest thought!' For Tàpies darkness took on increasing importance, and the meaning of his art became ever more opaque. However, precisely by virtue of its obscurities his work offers ample scope for the free play of association. Even Diderot, that staunch defender of Enlightenment values, called upon the artist to leave 'a gap for my imagination to fill'.

THE WALL AND THE PAINTINGS
RESEMBLING WALLS

The major turning point in Tàpies's artistic development occurred when he returned to the ideas which he had begun to explore in his early collages and in his *art brut* paintings, with their graffiti-like elements. His technique became more economical, the colours darker, and he gradually replaced figuration with cipher and allusion. This change of direction was partly triggered off by a crisis following his second one-man exhibition at the Laietanes gallery in Barcelona in 1952. The response of the public and the press was disappointing, and not a single picture was sold. Tàpies wanted to start again from scratch. However, the break with the past was far less abrupt than he intended. There was a transitional phase during which he painted a number of pictures that were heavily influenced by Miró: here, the drawing no longer stands in

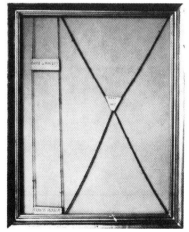

Fig. 26 Francis Picabia, *Tabac-Rat* or *Dance of Saint-Guy*, 1919/21

Fig. 27 Francis Picabia holding the restrung version of *Tabac-Rat*, 1949

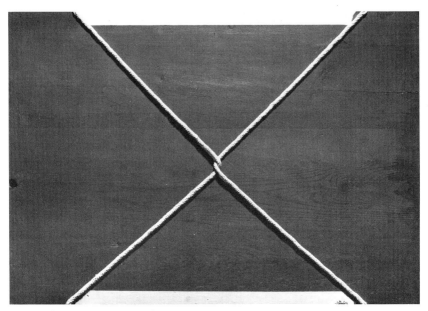

Fig. 28 *String crossing on wood*, 1960

isolation, set against an empty surface, but merges into the background, which is executed in a painterly manner with a dark, textured surface. The works are done in charcoal, watercolour or gouache on paper or cardboard. Their backgrounds prepared the way for the paintings in thick impasto that were to dominate Tàpies's work from the mid-1950s onwards.

The intellectual impetus for these innovations came from Paris. Tàpies had visited the French capital for the first time in 1950, when he stayed there for a year on a French government scholarship. Following this, he returned several times to Paris, where he found a wide range of things to stimulate his imagination: he went to exhibitions, met other artists – it was at this point that he encountered Picasso for the first time – and was able to read art magazines that were difficult to obtain in Spain.

The concern with walls, and the paintings with rough impasto surfaces that resembled walls, accorded with the Existentialist spirit of the post-war years, which found its principal literary expression in the work of Sartre. This was also the time when Brassaï published his photographs of graffiti (see fig. 29), speaking of the 'universe of walls'. It was the Dadaists who had pioneered this kind of 'poor' art after the First World War: following in the footsteps of the Cubists, they had completely over-turned conventional notions concerning artistic materials. Cardboard, wire, rope, rusty nails, sand – every conceivable kind of commonplace material found a place in art. The collages of Schwitters were art from the junk-heap. Picabia took up the idea and gave it a more provocative

twist in his abstract compositions, such as that of 1919/21 which used lengths of cord stretched over a piece of plain brown cardboard (fig. 26). In the 1930s Miró executed pictures in sand, tar, casein and oil paint on a cement ground or on rough, dark sandpaper. At the same time Brassaï was going out hunting graffiti with Picasso. In 1933 he wrote: 'The hermaphrodite art of the alleys is taking on the status of a criterion. Its law is binding, and it throws all the cleverly reasoned principles of aesthetics straight out of the window.'[11]

It was Brassaï's photographs of walls which led Tàpies to see the wall as an emblem of contemporary life. In the mid-1940s Jean Dubuffet had reacted in a similar way with his first impasto pictures: surfaces of clay, cement and earth full of stones, with roughly etched inscriptions and awkward, stick-like figures – motifs of the kind one could find on walls almost anywhere, if one only opened one's eyes to this form of *art brut*.

In Paris Tàpies came into direct contact with all these new trends in art: his previous acquaintance with them in Barcelona had been limited

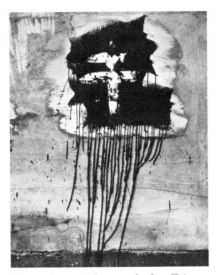 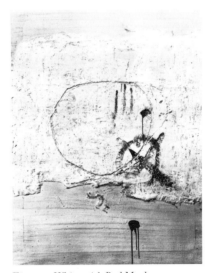

Fig. 29 Brassaï, photograph of graffiti, 1930/39

Fig. 30 *White with Red Marks*, 1954

to seeing occasional reproductions. He also encountered the paintings of Jean Fautrier, with their *haute pâte* technique which strongly emphasizes the material quality of paint.

Significantly, however, it was in Barcelona that Tàpies created his first impasto paintings, in 1953/54 (see fig. 30). They owed their inspiration to the high walls, the austerity, the mystical remoteness of Spain – or, to be more precise, Catalonia – rather than to the enlightened spirit of France and the charm of Paris. Tàpies's theme was not 'matter' itself: instead, the rough impasto surfaces, scored and imprinted, their paint mixed with straw, sand and other materials, were a vehicle of expression,

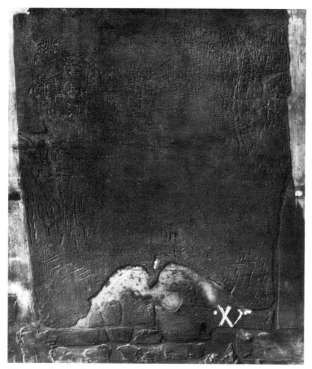

Fig. 31 *Large Grey Painting No. III*, 1955

a kind of language through which he sought to communicate his herme-
tic ideas, his feelings, his intellectual attitude, and to speak of his cultural
heritage. He began to mix earth, glue and marble-dust into the paint,
thereby giving it a consistency with enabled him to depict the world of
walls, of closed doors and shuttered windows. Right from the outset
Tàpies took the reality of Spain, or Catalonia, as the basis of his pictorial
world; however, since he paints it without distance or perspective, it is a
world which at the same time appears abstract, even surreal. He unveils
an alternative, hidden reality beyond the external world of appearances,
which is reduced to a set of schematic signs.

In 1954 Tàpies committed himself entirely to this form of painting,
which in a sense constitutes an abandonment of painting. The blank wall
is at once a motif, a theme and a technique. It requires a large format,
which was a new departure for Tàpies. When he embarked on these
pictures, his painting lost its colourfulness and transparency. It became
compact and took on the character of raw matter, replacing the coloured
illusions of his dream pictures. Instead of oil paint, he began to experi-
ment with mixed media, using a variety of tools to scrape and scratch and
cut and layer the surface. His impasto pictures were no longer canvases
but massive, bulky objects which introduced the tactile qualities of sculp-
ture into painting. One of his first pictures resembling a wall was *Large*

Grey Painting No. III (fig. 31), done in 1955 using mixed media with sand. The work has the appearance of a lump of masonry, with the simulated outlines of bricks showing under the plaster.

The economical yet powerful language of materials in these relief pictures is anticipated in Tàpies's early collages and *graffages*, where he uses string and cord, rice, newspaper and toilet paper to make objects which resemble fetishes. These fragile, small-format collages, produced from 1945 to 1947, indicate Tàpies's preference for natural materials with a rough, matt surface – materials which convey associations of warmth and are subject to a visible ageing process. Tàpies has always eschewed metals or any other materials with smooth, shiny surfaces. The only way of exploring these tableau-objects is by touch, sensing the specific aura which surrounds so many of his works. They seem to create their own microclimate, like objects which acquire beauty, life and presence only through use. Tàpies has never taken any interest in plastics because they are so difficult to shape in accordance with the artist's individual wishes. The only exception to this rule is the synthetic paints which he has often used in recent years. They contribute a sense of fluidity, which is entirely excluded from the early, hermetic impasto paintings, where movement is replaced by the traces of age: thus, the past becomes visible in the present, and one sees change in the midst of continuity.

THE CATALAN HERITAGE

A walk through the Gothic quarter around Barcelona Cathedral – through Carrer Obisbe Irurita and Pla de la Seu, where the Catalans perform their national dance, the *sardana*, after church on Sundays – constitutes a better introduction to the work of Tàpies than any art historian could ever provide. In his impasto paintings Tàpies has repeatedly captured the spirit of the old Barcelona: the austerity and gloom of the city, that mysterious, forbidding air emanating from the tall rows of houses in the dark, narrow streets, which at midday are deserted, as if a curfew had been imposed for the early hours of the afternoon. These streets have an atmosphere in which elements of the past still survive: not only the beliefs and superstitions of the Middle Ages, and the power of the Inquisition, but also the spirit of revolt which has left its mark on the paving-stones, the walls and the gates.

Tàpies spent part of his youth here. His grandfather owned a bookshop in Plaça Nou, opposite the Cathedral. The impasto paintings resembling walls are a dialogue with the history of the country, a history which is integrated into the lived experience of the present; in addition, their rough, relief surfaces trace out a path of memory which leads back

Fig. 32 *Circle and Cross*, 1968

Fig. 33 *Sardana (Circle of Feet)*, 1972

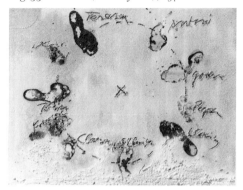

into the artist's own childhood and early youth. On several occasions Tàpies has recalled how, as a boy, he felt 'shut in by walls': 'In the city which, through habit and family tradition, was so much my own, the walls were witnesses to all the torments and the reactionary inhumanity that our people were forced to endure.'[12]

At the outbreak of the Spanish Civil War Tàpies was just thirteen. Within a few months the rebels gained control of a third of the country, enjoying particularly strong support in the western provinces. Barcelona was a stronghold of Republicanism and stubbornly resisted Franco's armies until January 1939, shortly before the final surrender of the Republican government.

These political events are crucial to an understanding of Tàpies's work, especially of the early impasto paintings which take the wall as their theme. Tàpies is a person who thinks in political terms: this is

Fig. 34 *My Friends*, 1969

Fig. 35 Max Ernst, 'Max Ernst's Favorite Poets [and] Painters of The Past', *View*, 1941

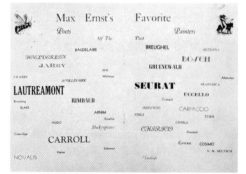

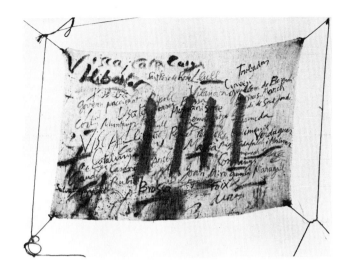

Fig. 36
*Inscriptions
and Four Lines
on Jute,*
1971/72

clearly apparent in his pictures, his sculptures and, above all, his posters. A direct indication of his political views is to be found in *Suite Catalana*, the series of five aquatints he created in 1972. These prints are packed with allusions to the Catalan ideal of freedom and to the region's striving for autonomy: fingermarks and footprints, letters and names, the red and yellow of the Catalan flag. One of the integral elements in Tàpies's iconography is the motif of four red fingermarks on a yellow ground, which refers to a legend concerning the Count of Barcelona, who, when wounded in battle, daubed four bloodstains on his yellow shield and decreed that this should become the device of the national flag. Tàpies has used the motif in a wide variety of materials, including even knotted rags (see fig. 51).

The footprints of the *sardana* dancers belong to the same tradition (see fig. 33). This Catalan folk-dance, in which the performers dance round in a circle, holding hands, also featured in the *jocs florals*, the bardic competitions which used to be held in the region. The work of Tàpies keeps the memory of these ancient traditions alive, for example by citing the great names of Catalan history, especially those of poets, beginning with Ramon Llull and Ausiàs March, who made an important contribution to the flowering of culture in the era of the Catalan-Aragonian Empire. The monastery and training college for missionaries at Miramar, founded by Llull, became a major focus of intellectual life. Other such cultural centres included the monasteries of Santa Maria de Ripoli, Sant Miquel de Cuixà and Sant Martí de Canigó.

These and other names, such as those of Jordi de Sant Jordi and Barnat Metge – two poets of the old Catalan empire, which forfeited its autonomy in the sixteenth century when the royal houses of Aragon and Castile were unified under the *Reyes Católicos* Ferdinand and Isabella – are to be found in the picture entitled *Inscriptions and Four Lines on Jute,*

which Tàpies painted in 1971/72 (fig. 36). Here, Tàpies cites over forty names which are important to the history of Catalonia or hold a personal significance for him. In addition, the four thick, red vertical stripes of the Catalan flag unmistakably indicate that the work is intended as a homage to the region. The picture resembles Max Ernst's double-page contribution to the magazine *View* (fig. 35), an imaginary *rendez-vous des amis* in which the artist listed his favourite poets and painters. However, Tàpies's picture also has a distinctly political character. Like an anarchist banner, it is tied to the stretcher with cords at each corner. At the time when it was painted the work was indeed a form of political demonstration, a gesture of public support for the Catalan separatist movement which Franco was endeavouring to suppress. This is emphasized by the inclusion of the artist's name at the end of the list of poets, philosophers, theologians, politicians, architects and institutions which have a central place in Catalan history or have helped to keep the traditions of the region alive.[13] There are two variants on this picture, the titles of which openly state the artist's intentions. *My Friends* (1969; fig. 34) is a small work on paper combining the freely flowing lines of Surrealist *écriture automatique* with fragments of semi-legible script. *The Spirit of Catalonia* (1971; plate v), a large-format picture on canvas, is painted in the colours of the Catalan flag.

Tàpies identifies strongly with Catalonia, constantly emphasizing that Catalan, rather than Spanish, is his native language. This, for him, is more than a matter of defending his cultural heritage; it stems from a general desire for a sense of belonging, a need for the easy intimacy of familiar surroundings. He was born and bred in Barcelona and has lived there ever since. For him exile was never an option; he is constitutionally unsuited to living abroad and, although he travels to see his own exhibitions, he has no inclination to discover other countries. He has always been a traveller in the spiritual rather than the geographical sense.

At an early age Tàpies was diverted from the normal path of middle-class life by illness, which steered him towards an artistic career. However, he has never really abandoned the framework of middle-class habits and attitudes. Tàpies is no bohemian: he has always clung to the forms of support offered by tradition, by his family and the familiar surroundings of his native city. Although his art is concerned with a quest for new spiritual horizons, it retains a firm sense of physical place.

CIPHERS, BLOTS AND SCRIBBLES

As well as the hermetic impasto paintings, Tàpies has done a large number of works on paper: drawings, watercolours and collages whose fragmentary, fleeting, seemingly random character contrasts with the

heavy, static quality of the carefully composed impasto paintings. These works are not finished artistic products: rather, they depict the creative process itself as it emerges from the tension between form and formlessness, between the concrete and the abstract. Particular importance is accorded to line, which takes a variety of forms, ranging from the bold, energetic stroke of the pencil or brush, establishing definite contours, to the furious crossings-out in some pictures and the abstracted scribblings in others, which come straight from the unconscious. In these works on paper Tàpies also assigns a major function to blots in the creation of evocative effects.

In the past many artists have remarked on the effect of unmotivated, random marks in stimulating the creative imagination. Leonardo, for example, spoke of the suggestive power of stains on walls: 'you may discover a resemblance to ... an endless variety of objects, which you could reduce to complete and well drawn forms. And these appear on such walls confusedly, like the sound of bells in whose jangle you may find any name or word you choose to imagine'.[14] This, in turn, reminds one of Tàpies's dictum that it is impossible to see the world properly unless one has an inner mental image of it. Turner, who, like Blake, had studied the mysticism of Jacob Böhme, also discovered a source of inspiration in the random blot. A contemporary account describes how Turner began his watercolours by saturating the paper with wet colour, then, 'like one possessed', scratched, scribbled and scraped everything into an apparently chaotic state until, 'as if by magic', the motif emerged.[15] Victor Hugo was another artist who could conjure entire visions out of ink-blots. Concerning a drawing of this kind which he did in 1865, he noted in his diary: 'At five o'clock in the afternoon, with no light, drew what I saw on the wall.'[16] These parallels with the work of Tàpies have not been picked out at random: Tàpies has studied both the art and the writings of Leonardo, Turner and Hugo.

A further characteristic which plays a more prominent part in the works on paper and cardboard than in the impasto paintings is the 'scriptural' element naturally associated with paper. Tàpies is fascinated by written signs of all kinds: from scribbled notes on telephone message pads and torn, crumpled shopping lists to elegant calligraphy on Japanese vellum. And he loves books, not only for their content, their function as partners in an intellectual dialogue, but also for their visual and tactile qualities as aesthetic objects. He has designed several books in collaboration with writers, notably his friend Joan Brossa. Needless to say, he is not content to act as a mere illustrator: his aim is to establish a rapprochement between poetry and painting. The very titles of these books, which Tàpies generally packages in cardboard or wooden boxes, indicate their relationship to his own language of images and materials. The titles are ambiguous metaphors or, in many cases, oxymorons, dialectical combinations of words which trigger off a flow of associations. Nouns

Fig. 37 *Velvet with Signs*, 1978

can be read as adjectives and vice versa: the words become interchangeable, taking on a variety of meanings and stimulating the reader's imagination. For example, one of the works by Brossa for which Tàpies did a set of etchings is entitled *Nocturn matinal*, which could mean either 'morning nocturne' or 'nocturnal morning'. The titles of the books by Octavio Paz, Shuzo Takiguchi, Pere Gimferrer and Rafael Alberti are similarly ambiguous: *Petrificada petrificante* (The Petrified Petrifying), *Llambrec material* (Material Flash), *La clau del foc* (The Key to the Fire) and *Retornos de lo vivo lejano* (Return from the Living Farness), a volume of poetry written by Alberti when he was living in exile.

Diderot described poetry as a 'tissue of hieroglyphs' with the same 'rhythmical magic' as the interaction of colours in painting. This conception of the relationship between poetry and painting was later taken up by Baudelaire; subsequently, it was given a more radical twist by Rimbaud and especially by Mallarmé, whose projected *Book* envisaged a revolution in language, converting words into pure graphic signs and thus relocating poetry in the sphere of visual art. The same idea informs the highly unusual book *Novel.la*, which Tàpies designed in co-operation with Brossa. As its title (the Catalan spelling of the Spanish 'novela') indicates, the book is a novel, but it is a novel without words, taking its language from the suggestive power of the visual image.

In its sublime, poetic disregard for order and neatness, the book is an affront not only to the reader, but also to the bibliophile: its pages are dog-eared and tattered, covered with scribblings and stains. It lays bare the workings of an imagination which feeds on chaos, but which at the same time has an alternative identity, rooted in the ordered, bureaucratic world where individuality is expunged and life is recorded in terms of official documents, certificates and diplomas. *Novel.la* is an anti-book which takes its inspiration from Dada and Surrealism. Michel Foucault remarked on the astonishing contemporary phenomenon of the communication between two discourses, that of madness and that of literature, which previously had always been regarded as incompatible. He cites the example of Raymond Roussel, who, on the very day before he committed suicide, wrote an essay entitled 'Comment j'ai écrit certains de mes livres', systematically linking an account of his madness with an explication of his literary method. Many of the Surrealists, notably Breton, Eluard, Aragon and Masson, spoke of the creative potential of madness, which they attempted to simulate through the device of *écriture automatique*. Tàpies has employed the same technique.

As an attempt to plumb the depths of the subconscious mind, 'automatic writing' introduces a 'scriptural' element into painting. This has become an integral feature of Tàpies's work. His pictures are strewn with letters, numerals and hieroglyphs which form a mysterious alternative language. These scriptural signs have an associative significance: the normal communicative function of language is largely suspended, and the meaning of the signs consists precisely in their enigmatic quality. The riddle becomes a principle of communication.

In addition to scraps of writing, Tàpies's pictures include cryptic signs, such as footprints (see fig. 6o) and palmprints. Like the crossed-out slogans, these images conjure up associations with a specific reality. In Spain burial shrouds are marked with the footprints of the deceased, which serve as a means of identification. One is also reminded of the footprints of the Buddha which are carved in the path around Buddhist temples. The numbers, too, are laden with allusions. In many cases they refer to magic formulae or methods of fortune-telling: one thinks, for example, of the *dau al set*, the die with seven numbers. Tàpies and Brossa share an interest in games of chance and the tricks of conjurers and magicians. Together, they have produced a book about the conjurer Frègoli (see fig. 76).[17]

The numbers in Tàpies's pictures also frequently refer to counting games. In Taoist painting numbers signify the idea of change. This, again, is a continuing theme of Tàpies's art.

Both Tàpies's house in Carrer Saragossa and his country home in Cam-
pins on the slopes of Montseny, not far from Barcelona, are crammed
with objects from all over the world: small exotic sculptures and fetishes,
votive offerings, various types of vessels, *netsuke* figures, magicians' and
conjurers' props. They cover the shelves and cupboards; the walls, too,
and even the ceiling are festooned with objects such as the oversized shoe
mentioned above, knotted rags, fans and Japanese paper kites. The effect
is like that of a still life. This is also the case with the things which lie
strewn around Tàpies's studio: an old baking-sieve, bits of rag, tools and
paintpots, a heap of marble-dust, the artist's slippers.

In several different ways Tàpies has taken artistic possession of the
object, even placing it in a kind of aesthetic seclusion. The objects in his
pictures look walled-in; the ceramic sculptures of the 1980s have a pet-
rified appearance (see fig. 40); and the tableau-objects and assemblages
with pieces of furniture which he made at the beginning of the 1970s
have the magical character of fetishes (see fig. 62, 80, 89). What all these
works eschew, however, is the quality of humour.

The objects in Tàpies's work are sealed off from the outside world and
depicted in a manner which abolishes spatial distance and perspective,
creating an effect like that of a blank wall with closed doors and win-
dows. The same hermetic view of the object, which breaks through the
viewer's detachment and induces a meditative attitude, can be found in
early Spanish still-life painting. In the pictures of Fray Juan Sánchez
Cotán (1591–1627) fruits and vegetables take on the character of magi-
cal objects. As in the work of Tàpies, this effect stems partly from the way
in which the objects are isolated and placed in front of an indeterminate
dark background. Substituting plainness for diversity, and dispensing
with all forms of luxury and indulgence of the senses, the art of Sánchez
Cotán, like that of Tàpies, is strongly influenced by Spanish mysticism.[18]
The closed boxes and vessels in the still lifes of Juan van der Hamen y
Leon (1596–1630) are also motivated by religious ideas. These simple
objects, which are removed from any practical context, are surrounded
by an empty darkness that lends them an aura of monastic asceticism
and humility.[19]

A further interesting feature of these sixteenth- and seventeenth-cen-
tury still lifes, which differ so markedly from their sumptuous Flemish
counterparts, is the way in which they negate the object as commodity,
thus anticipating the 'poor' art of Tàpies. The object has no material
value: instead of being held up for public admiration, it is transposed into
the realm of mystery and thereby stripped of its everyday function.

Discussing the still lifes of Sánchez Cotán and van der Hamen y Leon,
Jutta Held singles out two important points that in turn serve to indicate
the extent to which the art of Tàpies is rooted in the cultural life of Spain.

On the one hand, she emphasizes the character of Spanish mysticism as an underground opposition movement within the Church, helping to bring about a reinterpretation of orthodox values, and, on the other, she remarks on the strict ceremonial conventions of the Spanish court, which had certain features in common with mysticism: 'The overladen tables in Dutch still-life painting, from which people are allowed to help themselves as they please, seemingly correspond to a bourgeois notion of luxury In the feudal rituals of the Spanish court, each course became a meal in its own right, each dish and each table implement was individually celebrated as something precious and mysterious All the dishes remained covered, so that nobody knew what they contained, until, amid

Fig. 38 *Red and Black
with Tears*, 1963/65

further solemn ceremony, they were presented to the King for him to make his selection.'[20]

The complete absence of decoration in these Spanish still lifes, the darkness and emptiness, and the resulting reduction in colour, are linked with the mystical tradition. The mystics took the view that the hand of God revealed itself in the simplest, most commonplace things, in raw nature rather than in the precious objects created by the exercise of human skills. This preference for plainness over ornamentation directly contradicted the feudal traditions of the Catholic Church. A further controversial issue was the mystics' emphasis on darkness, which they regarded as an aid to spiritual enlightenment. Saint John of the Cross, for example, saw darkness as facilitating meditation by acting as a stimulant to the imagination, hence enabling the subject to enjoy the experience of heightened perception described by one of the saint's own pupils, a nun called Cecilia del Nacimiento, who was also a poet and painter. Cecilia wrote: 'I saw everything with such sharpness that it was as if I had the

eyes of a lynx, mysteriously penetrating to the very heart of things.'[21] This description closely resembles the answers which Tàpies gave when questioned about his rejection of colour and his attitude to the object. His aim in painting is to penetrate beyond the superficial appearance of things, and this calls for darkness instead of colour – that darkness which, to the mystic, is the bringer of light, by the same paradox which decrees that the goal, the absolute, the ultimate ground of being is the most perfect emptiness.

This mystical, dialectical view of perception and knowledge has a bearing on a further issue which Tàpies frequently raises: the question of the relationship between his art and Eastern thought. In many respects Western mysticism is closely akin to Eastern philosophy: both systems of thought seek to break down the barriers between subject and object, between the self and the world, between the conscious and the unconscious mind. Via the discoveries of psychoanalysis, the Surrealists arrived at a similar set of ideas.[22]

The materials and objects which Tàpies uses in his art are never new, nor are they elegant. They are crude and humble in origin and character. His 'poor' art constitutes a defence of valueless things in a world of material abundance. It differs fundamentally from Italian *arte povera*, which uses the contrast between crude materials and shiny, immaculate industrial artefacts to create a poetry of surface effects with a direct visual and tactile appeal. This is quite unlike the 'poor' art of Tàpies, which negates sensuous qualities of this kind: hence, his work appears altogether tougher and more austere, emanating an aura of sacrifice and humility.

As early as the mid-1950s Tàpies began to address the object in sculptural terms. In 1956, barely two years after painting his first impasto paintings with fragments of graffiti, he created the large assemblage entitled *Metal Shutter and Violin* (plate 11). However, it was not until the early 1970s, when interest in Dada was revived by American 'combine' painting and by *Nouveau Réalisme* in Europe, that the object resurfaced in Tàpies's work with a comparable degree of emphatic reality, resulting in the production of a series of object-paintings and furniture assemblages. Meanwhile, though, Tàpies continued to concern himself with objects in painting, using such motifs as doors, gates, bedsteads, chairs, hats, caps, sacks and book-bindings.

CLAY SCULPTURES

At the beginning of the 1980s Tàpies decided to take up sculpture, using clay as his preferred material. This marks a further step in the progress of his art towards the liberation of the object.

The first of these clay sculptures were made in 1981 in the small town of St Paul-de-Vence in the South of France. Two years later Tàpies produced an extended series of similar works at Gallifa, a mountain village near Barcelona, in the studio of Joan Gardy Artigas, where Miró had also made his ceramic sculptures. The particular attraction of this studio is its wood-fired kiln, the type favoured by Japanese potters because of the effect of the wood-ash on the glaze.

At an early stage, however, Tàpies also drew on the experience of the German ceramic artist Hans Spinner, who runs a potter's studio near Grasse in the South of France which was opened in 1984 by the Galerie Lelong. Spinner's studio has two kilns, one of which is powered by electricity, while the other can be fired with either wood or gas. It is here that Tàpies has made all his subsequent ceramic works, producing them in batches of up to forty, with each batch taking a week to complete.

The studio is located in a tall, narrow house in the countryside, an eighteenth-century shooting-lodge of the kind often found in the region. In later years the original building was extended on all four sides, giving it the appearance of a church, with low annexes grouped around the tower and a wrought-iron cross above the gable-end. One of these annexes, immediately abutting the main building and with a sloping slate roof, houses the electric kiln. However, Tàpies often works outside in the garden, where the wood-fired kiln stands.

It is less than surprising that Tàpies should take an interest in ceramic sculpture, which for many years has occupied an important place in the artistic traditions of the Latin countries. French, Italian and Spanish painters and sculptors, led by Auguste Rodin and Paul Gauguin, began

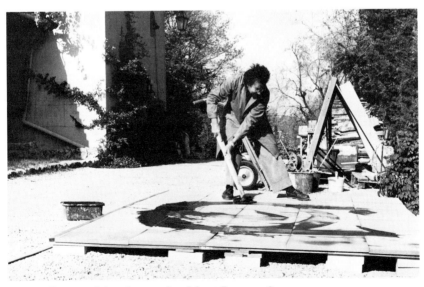

Fig. 39 Tàpies applying glazes to clay slabs at Grasse, 1985

to experiment with pottery in the later decades of the nineteenth century, and ceramic sculpture was taken up at the beginning of the twentieth century by a whole series of painters, including Matisse and, at a very early stage in his career, Picasso. However, the interest of these modern artists in ceramics was initially confined to the decorative possibilities of the medium. They painted on rough-glazed items of pottery, such as plates and vases; occasionally, as in the case of Matisse, they also did full-scale ceramic pictures.

Tàpies worked in the same studio and used the same material as Eduardo Chillida, who had embarked on a series of massive clay sculptures eight years previously, in 1973. The raw material is lava, cut into 50 x 50 or 100 x 100 centimetre slabs. These are covered with a layer of clay, glazed with various slips and oxides, which Tàpies applies with a brush, a broom, a sponge, or even a crude lump of wood (see fig. 39, 108). For the heavy graphic marks he uses a power grinder, adding smaller scratchmarks with a comb.

With these ceramic works Tàpies returned to the wall and the object. He no longer had to simulate the appearance of a wall by layering paint on a canvas or by using collage; instead, the slabs of lava have a ready-made stone surface. At the same time, the raw clay is so soft that it can be shaped into any kind of object the artist pleases.

Tàpies's experience of handling clay and earth also affected his painting, which had seen no major changes since the mid-1950s, the time when he produced his first impasto pictures. Until the early 1980s he continued to use the same pictorial and material vocabulary; the only thing that changed was the expressive quality of his painting, which had been stronger in the early works, with their brusque, uncompromising manner. In recent years, however, he has taken much of the heaviness out of his pictures, gradually replacing the hermetic paintings, whose motif and materials both convey a positively palpable sense of impenetrability, with pictures in which he uses flowing, matt colour to create a new clarity and transparency. This development is directly linked to the ceramic works: it is the clay sculptures which now embody the hardness, the hermetic form, the austerity of expression which formerly characterized Tàpies's paintings. At the age of nearly sixty Tàpies discovered a new challenge in the hard, unyielding material of his sculptures, a challenge of a more direct kind than painting could offer after decades of using the same tried-and-tested graffiti technique.

In his experiments with clay sculpture Tàpies has devoted much time to exploring the specific properties of the material. Like his predecessor Miró, he has continually sought to devise new techniques of painting, incorporating unconventional materials into art. An example of this is his use of marble-dust to thicken the colour in his paintings and create a surface which refracts the light. In his clay sculptures he uses a somewhat similar technique. About sixty per cent of the clay mixture is pow-

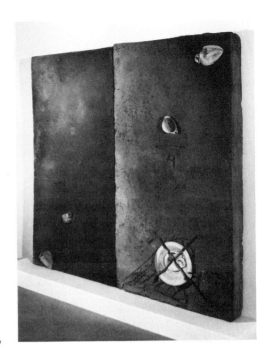

Fig. 40 *Diptych*, 1983

dered clay that has already been fired. Thus, the surface of the finished
work, when it comes out of the kiln, is as hard as stone, which enhances
the expressive quality of the sculpture and makes it possible to create
massive, severe forms.

When Miró made his first ceramic sculptures in the early 1940s he
began by experimenting with the possibilities which the new technique
offered in terms of form and colour. From the outset, colour was a
particularly important consideration. Miró initially made a series of large
vases and pictures composed of painted tiles, which were followed by
clay sculptures based on copies, made by Joan Gardy Artigas, of various
objets trouvés. Over the years, as his technique evolved, Miró's sculptures
took on an increasingly architectural quality; he also started to produce
bigger formats by joining several blocks together after firing them.

Like Miró, Picasso approached ceramics with the eye of a painter. In
the 1940s, working in the studio of Georges and Suzanne Ramié at
Valauris, he made a series of vases and plates which he then painted, as
the Fauves had done. To him the form of the object was merely a surface
to paint on: what interested him, as Werner Spies records, was the
specific quality of the colours, the action of the light on the glaze and the
finality of the painting once the work went into the kiln. Subsequently,
Picasso produced a second group of ceramic works based on vessels,
such as vases, which were made on a potter's wheel and then modified in
a variety of imaginative ways. The artist changed the shape of the vessels
to give them a deformed appearance, added on bits of extra modelling

and decorated the works with paintings of funny faces, plump bodies and grotesque gestures.

Unlike Miró and Picasso, Tàpies has largely abstained from making ceramic utensils. Modelling pots on the wheel and painting on sculptural forms hold little interest for him. He has made only a small number of works on the wheel, including a sack, a scroll and a few abortive plates and cups which he integrated into a mural relief. Colour, too, is largely absent, apart from black and grey – negative colours which have no painterly function and are used only for line, script and gesture. Tàpies is principally concerned with the surface, with the material qualities which manifest themselves when the clay is fired, producing a variety of cracks, fissures and holes. The first ceramic works he produced, in 1981, were mural reliefs and tiled friezes, over three metres long, which were clearly still based on painting. Two years later Tàpies created two further mural works: a large tableau measuring 250 x 375 centimetres, composed of several lava slabs joined together, and a diptych made of fireclay, measuring 142 x 152 centimetres, with crushed earthenware cups and plates set into the surface (fig. 40). The latter work is too heavy to hang up: it can only be stood against the wall, with the base resting on the floor. The sculptures which followed are almost entirely independent of the wall. These later works are massive, square forms representing, or at least alluding to, pieces of furniture, as indicated by their titles: *Chair* (see fig. 41, 43, and plate VII), *Cupboard*, *Sofa* and *Bed*. Made of natural-coloured fireclay with touches of black paint, the sculptures have a

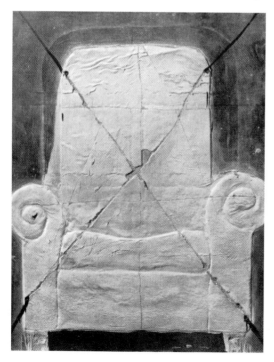

Fig. 41 *Matter-Armchair*, 1966

46

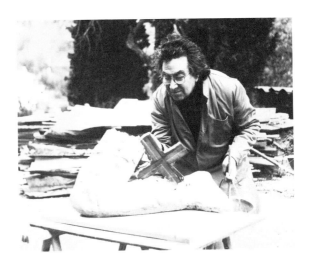

Fig. 42 Tàpies working
on the sculpture
Leg and Cross
at Grasse, 1986

heavy, earthy presence. They exhibit a conspicuous restraint in the use of colour, a characteristic of all Tàpies's ceramic works to date.

The next group of sculptures which Tàpies created are the stelae, which take five different forms, ranging from the cross to the plain upright slab (see plate VIII). These works have the character of hieratic signs with a deeply serious import: in respect of their form and their expressive power they mark a pinnacle of achievement in Tàpies's sculptural oeuvre. They were followed by a number of objects which resemble

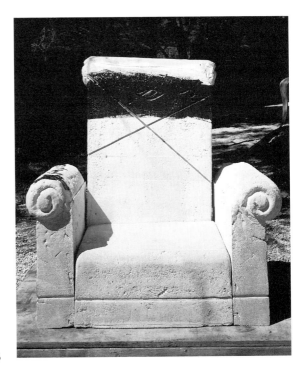

Fig. 43 *Armchair*, 1985

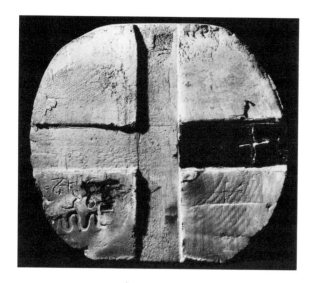

Fig. 44 *Stela with Cross*,
1983 (obverse)

packages and allude to books and scrolls, motifs which are connected
with the artist's love of literature and his reverence for precious old books
as *objets d'art*.

A quite different theme makes its appearance in the objects based on
parts of the human body: the leg, the foot, the skull and the torso (see
fig. 42, 66, 94). Tàpies's motifs are invariably inspired by reality. He
defamiliarizes the object by fragmenting it and turning it into an abstract
form, rather than deforming it or adding imaginative bits of modelling in
the manner of Picasso and Miró. There is nothing humorous or playful
about these sculptures. Their crucial significance lies in the way that they
detach the object from any kind of pictorial setting and present it in a
state of total isolation. Naked and ponderous, it stands in a void which
emphasizes its hermetic impenetrability, a quality which at the same
time is seen to be a supreme embodiment of concentration, individuality
and anonymity.

At various times, especially in and around 1970, Tàpies has produced
assemblages which treat objects as objects, rather than turning them into
abstract signs of the kind which one finds in his pictures from the 1950s
and 1960s. These works are made from a variety of *objets trouvés*, delib-
erately simple, commonplace items with plain, severe forms, such as a
chair with a pile of dark clothes, a bundle of old cloth tied up with string
(fig. 56), a desk heaped with straw (fig. 89) or a wardrobe door with a
mirror, scattered with brightly coloured confetti (fig. 91).

Familiar objects of this kind reappear in Tàpies's clay sculptures, but,
as in his pictures and assemblages, their significance remains undefined,
despite their palpable material identity. There is a sense of remoteness
and detachment about them, an aura of impenetrability which corre-
sponds to their squat and bulky outward form. Tàpies has always avoided

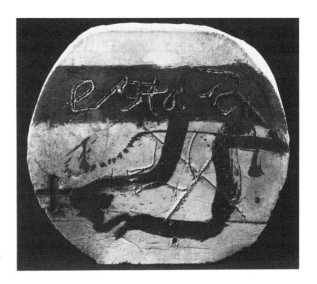

Fig. 45 *Stela with Cross*,
1983 (reverse)

open, spatially expansive forms. The dominant presence in his art is not empty space, but silence: behind the sign, or between the sign and the signified, there lurks an unknown something, shrouded in secrecy.[25]

This air of impenetrability characterizes both the objects which resemble bodies and the parts of the body which have been turned into anonymous objects. The effect is the same, regardless of whether the object is a leg, a foot, a rump, a stela, a cupboard, a chair, a book or a sack. These sculptures are all made to a human scale. They do not overwhelm the viewer, yet they stand in his path as intimations of something else, something vast and colossal. The square, bulky shapes and the vertical lines of the stelae demonstrate an unwavering composure. Even where the forms are rounded, they never speak of submission, of bowing to the oppressor. The stela, the vertical т-shape (see fig. 98) which refers to the Saint Anthony cross and is the supposed form of the cross at Golgotha, is a sign of Tàpies's unbending attitude as a proud native of Catalonia. Thus, although he firmly repudiates religion, his work reveals religious undertones in the guise of mysticism. The sign of the cross has a significance similar to that of the sequence of notes b-a-c-h in the work of Johann Sebastian Bach.

The stelae, some of which are also round (see fig. 44, 45), rectangular (see plate viii) or horizontal, are the product of a quest for orientation. Here, to an even greater extent than in the impasto paintings, Tàpies emphasizes the centre, as a focus which defines the pictorial character of the work. This is also the case with other sculptures, such as *Cupboard*, *Cylinder with Sign* or *Two Blocks* (fig. 57), and with the works which take parts of the human body as their motif.

As in the impasto paintings, the surfaces of the sculptures have two levels of pictorial quality: on the one hand, the level on which the mat-

erial speaks for itself, using its own language, and, on the other, the level of line, inscribing graphic signs with exceptional firmness, severity and force. Form is created by scratches and grooves in the surface, by the differing textures of the clay and by lines of colour. Although the question of balance plays an important part in the shaping of the work, Tàpies eschews harmony, which is replaced by an effect of stillness resulting from the categorical opposition between the stable external form, supported by the graphic signs, and the dramatic internal structure, the varied textures of the flawed, porous material, which appears to seethe with life. In Tàpies's work architectonic restraint and austerity combines with free play of expression to form a unified whole.

The clay sculptures represent a transposition of Tàpies's previous motifs into another medium. In addition, they are a spirited attempt to explore the possibilities of a new material and of a technical process which is to some extent beyond the artist's control. The process of firing always leaves a certain amount of scope for the elements of chance and surprise. For example, the surface may look completely even before the work goes into the kiln, but, when the white engobe is fired, it invariably shows up the movements of the brush: by looking at the thickness of the glaze, one can immediately see where the brushstrokes begin. The colours also change: copper oxide with white engobe turns green when it is fired. The firing process involves a metamorphosis of form and matter, which is precisely what Tàpies aims to achieve in his art as a whole. Making a part of the human body into an object also constitutes a metamorphosis, a transformation effected by shaping soft, wet clay into a kind of stone monument, a sign which calls on the viewer to pause and reflect.

Few of Tàpies's sculptures are made in the conventional manner which allows the viewer to walk round the work and look at it from any angle he chooses. Instead, like the sculptures of Picasso, they have a definite front and back: they are impasto paintings in the third dimension, which have to be viewed from a specific perspective. This determines their location as objects designed to lie or stand on the floor or to be hung on the wall.

LINES AND KNOTS – THE STAGE SETS

'I remember one stage set which even I thought was very good. There was a large orchestra on the stage, and normally the musicians wore identical black tail-coats. My idea was that all these coats should suddenly be whisked up into the flies and remain hanging there in full view of the audience. The musicians carried on playing in their white shirts with all these black robes hanging above their heads.'

Fig. 46 Stage set design for *Or i Sal*, 1961

The stage set which Tàpies describes here was for a play by Joan Brossa and Josep Maria Mestres Quadreny entitled *L'armari en el mar* (The Cupboard in the Sea), which received its first performance on 17 October 1978 at the Teatre Lliure in Barcelona. It is one of four plays for which Tàpies has designed sets.[24] Three of the works in question were written by his friends, the avant-garde poets Brossa and Jacques Dupin; the fourth was a Noh play by the Japanese classical dramatist Zeami (1363–1443), which was staged at a theatre in a Barcelona suburb.

The first two of these stage sets were designed in the 1960s; the most recent one was for Dupin's *L'Eboulement* (The Collapse) in 1982. This was staged in Paris; otherwise, all the productions were mounted in Barcelona, and the plays were performed in Catalan. With the exception of a few photographs, the only record of this part of Tàpies's oeuvre consists in his drawings and his comments.[25]

Fig. 47 Stage set design for
 L'Eboulement, 1982

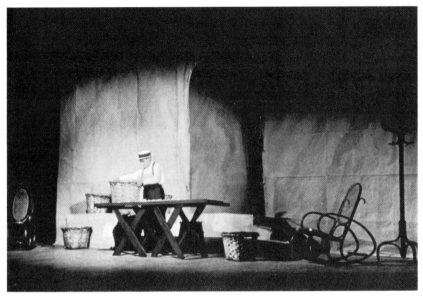

Fig. 48 Scene from the first performance of *Or i Sal*, 1961

The most striking thing about the drawings is the fact that they contain no indication of their function. It is not apparent that they are designs for stage sets: there is nothing to distinguish them from Tàpies's other pictures. They are two-dimensional compositions which make no reference to any kind of spatial situation or to the reality of a stage performance. This even applies to the props and items of stage furniture, objects which Tàpies otherwise endows with a magical presence in his pictures and, especially, his sculptures. In a manner which forms an interesting comparison with his other work, he negates the function of the objects in these drawings by reducing them to mere ciphers and lines. Apart from

Fig. 49 *Knot and String*, 1969

Fig. 50 *Tears*, 1970

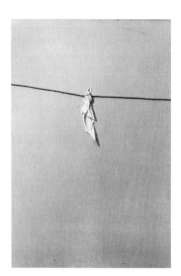

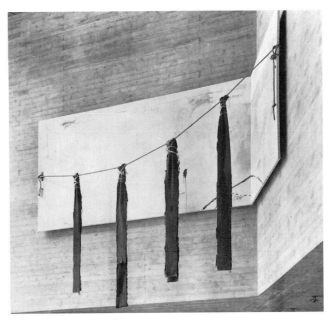

Fig. 51 *Large Corner Picture*, 1970

the above-mentioned scene from *L'armari en el mar*, where Tàpies styl-
izes the musicians' clothes and turns them into decorative objects, all his
set-designs are characterized by the same minimal signs – the letter x,
the line and the knot – with the stage itself remaining virtually empty.

Tàpies did his first stage designs in 1961, for *Or i Sal* (Gold and Salt),
a 'scenic poem' by Brossa. The play was performed in the Palau de la
Música Catalana, a large concert hall which is one of Barcelona's most
extravagant examples of Art Nouveau architecture. The austere simpli-
city of the stage design seemed like a deliberate attempt to counterbal-
ance this highly theatrical setting. There is an almost dramatic irony in
the fact that the same architect who was responsible for the Palau de la
Música Catalana – Domènech i Montaner, a contemporary of Gaudí –
also designed the building which now houses the Antoni Tàpies Founda-
tion (see fig. 52, 99, 100).

One of the designs for *Or i Sal* (fig. 46) is a rudimentary drawing, on a
light-coloured surface, of a door with a round arch set slightly off-centre
and above the bottom edge of the picture. Underneath it there are two
black crosses which, as the photographs of the production show (see
fig. 48), represent the legs of a table. In his other designs Tàpies
eliminates all reference to stage props of this kind: coatstands, chairs,
baskets and so forth.

'Theatre, for me, is like all the other art forms of the twentieth century.
I am interested in all the questions surrounding the idea of mimesis after
the invention of film and television. Consequently, I am also interested in

the "transgressions" which modern theatre perpetrates, and especially in the discoveries made by non-European forms of theatre. The West, unfortunately, has not yet had sufficient opportunity to acquaint itself with Noh theatre, or *kabuki* and *bunraku*, let alone Indian theatre or Chinese opera. There, as in music, a whole world lies waiting to be discovered which satisfies my need for modernity more thoroughly than all the plays in our cultural tradition.'

Significantly, the second theatrical work for which Tàpies designed the set was a Japanese Noh play, *Semiraru*, by Yuzaki Motokiyo Zeami, which received its first performance in Catalan translation at the Teatre de l'Aliança del Poble Nou. No photographs of this production have survived. In a letter to me Tàpies described the set as 'similar to a picture which I did at about the same time [fig. 49]. The picture consisted of a big white knotted handkerchief hanging from a cord which was stretched over a blank canvas. That was all. On the stage there were two lines, two cords running right across the set, with a knotted handkerchief on one side and a walking-stick on the other. These are objects which I have also used in paintings.'

Three years later, in 1970, Tàpies used the same idea of the line and knot in a picture which he produced for the city theatre in St Gallen in Switzerland (fig. 51). Designed to hang in a corner of the foyer, the 'combine' painting consists of four red rags tied to a rope in front of an almost bare canvas. The same year Tàpies produced a variant on this three-dimensional work entitled *Picture with Rags and String on Canvas*. The red rags in these two pictures, and the yellow ground of the latter work, conjure up the image of the Catalan flag.

Knots and lines, which have always interested Tàpies and appear in many of his paintings and other works (see fig. 50), became an integral feature of his stage sets. They occur again in the set which he designed in 1982 for Dupin's *L'Eboulement* (see fig. 47). The play, whose title means 'collapse' or 'debris', was performed in the refectory of the University of Paris. As the artist recalls, 'the set was in the same style as the others, but this time I used white sheets and lengths of string and added a few patches of colour Perhaps, in all these works, I was looking for line. We talked about line in my work a few days ago. You thought that it was less important in my earlier paintings. But there have always been lines in my work: lines etched into the coloured matter, impressions of thick cords, lengths of real cord and, in the case of the St Gallen picture, even lines in the third dimension. And perhaps they also play a part in the work which I plan to do for the Foundation, a sculpture, made of cables, for which the flat roof of the building is a possible site.'[26] The artist explains that he has always been fascinated by knots, ropes and cords: 'I studied them in a semi-systematic fashion by reading old nautical handbooks, where you find an incredible variety of knots, which are often very beautiful. A knot can symbolize the situation of man in the universe. It

can evoke the idea of agreement between viewer and spectacle. In my paintings I often use the image of the Möbius strip, the snake biting its own tail or the figure eight. Regarding the latter, there is a little pun that I exploit. The Catalan word for "eight" is *vuit*, which sounds very similar to *buit*, meaning "emptiness".'

The anthropologist and religious scholar Mircea Eliade has written about the many and varied symbolic meanings of lines and knots, looking, among other things, at the etymology of the words connected with these things.[27] In several languages the verb 'to tie' also means 'to enchant', to put a spell on somebody. Hence, the action of tying a knot has an essentially magical character. In connection with the theatre, Tàpies often speaks of 'bewitching' or 'spellbinding' the audience. He declares his preference for 'popular, para-theatrical forms which lie beyond the norm. But by that I don't mean we should destroy the classical forms of drama or perform everything on the street or in bizarre settings. On the contrary: I believe there is a great deal of magic and enchantment waiting to be discovered in the opening of the velvet curtains, in theatrical lighting and paper decorations and all the scenic games played on the conventional proscenium stage, which is like the inside of a mouth.'

These remarks by Tàpies are taken from a letter in which he commented extensively on his relationship to the theatre. The particular atmosphere of traditional theatre is also evoked in the book devoted to the conjurer Frègoli which Tàpies and Brossa produced in 1969.[28] Bound in red velvet, with Frègoli's arabesque signature running across the cover, the book is a nostalgic tribute to the world of the stage and the music-hall, a world of deception and illusion. In Tàpies's view theatre has its own innate artistic potential which must be preserved, instead of being destroyed by excessive intellectualism and political commitment: the stage, he says, is no place for 'messages'.

THE ANTONI TAPIES FOUNDATION

In January 1987 Tàpies announced the establishment of a foundation devoted to his own work – following the Picasso Museum and the Miró Foundation, the third museum in Barcelona to be dedicated to the work of a modern artist. The Antoni Tàpies Foundation was opened in June 1990 in a building at 225 Carrer Aragó which, erected in the nineteenth century to house a publishing company, had been extensively restored and renovated for its new purpose (see fig. 52, 99, 100). As one of the earliest examples of *modernismo* in Barcelona, it is a listed building. The city takes great pride in its architectural heritage and even supplies cardboard cut-out models of this and other historic buildings as a teaching aid for use in schools.

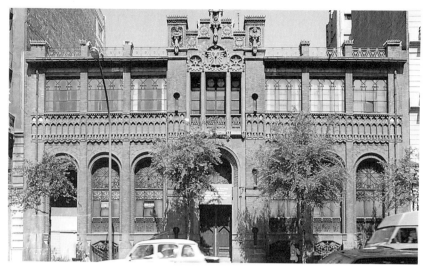

Fig. 52 The Antoni Tàpies Foundation in Carrer Aragó, Barcelona

Unlike the other two museums of modern art, the Tàpies Foundation is located in the heart of the city, in the main shopping and commercial district known as the *Eixample*, at the point where Carrer Aragó, a wide, busy boulevard, intersects two of Barcelona's finest streets, Rambla de Catalunya and Passeig de Gràcia, which are lined with elaborately ornamented Art Nouveau buildings designed by Gaudí and Puig i Cadafalch. Ideal as its situation may be, the building itself is a somewhat surprising setting for the museum, which contains a permanent collection of Tàpies's work from every phase of his career, together with an extensive library and rooms for lectures and other events. It is a gloomy red-brick edifice, built in the 1880s, which combines elements of the Gothic Revival style with more modern influences from the period when new methods of construction involving steel and glass were beginning to make an impact on architecture. The Neo-Gothic tower, with a parapet running round the top, makes the doorway look like the entrance to a church. There is nothing to indicate the original function of the building.

Tàpies, however, sees the building in a quite different light. It was designed by Lluis Domènech i Montaner, a contemporary of Gaudí and Puig i Cadafalch who, at the turn of the century, was one of Barcelona's leading architects. He was responsible for the Palau de la Música Catalana, the city's magnificent concert hall which, with its brightly coloured mosaic domes, its floral capitals and gilded stucco figures of trumpeting angels, does indeed resemble a palace, or a fantastic mosque. Montaner also built the hospital of San Pablo, a huge, fortress-like, red-brick structure with parapets, towers and heraldic elements.

Once again, Tàpies demonstrates his loyalty to tradition and his affection for his native city. This time, however, the object of his affection is

56

not the old Gothic quarter around the Cathedral, but the extravagantly ornamented fantasy architecture of the *fin de siècle*. For the Miró museum the artist's friend Luis Sert designed a modern building, full of space and light, which is set in the natural surroundings of the park at Montjuich and looks down on to the city. Although a building of this kind would undoubtedly provide an interesting framework of contrast in which to show Tàpies's work, the dark and mysterious walls of the city centre are more suited to his particular temperament. In conversation he remarked that he found the idea of a 'temple' appealing.

Tàpies is a hermetic artist; his art is a kind of secret writing which can be deciphered only by reference to the Spanish-Catalan tradition in which it stands. In order to understand it one has to look at the mysticism, philosophy and poetry which flourished in the monasteries of the Middle Ages, the earliest centres of culture in the region, and at the courtly ballads of the troubadours from the heyday of the Catalan empire, when Catalonia, allying itself first with Occitania and then with Aragon and Valencia, was a colonial power, with possessions in southern Italy, the eastern Mediterranean and North Africa.

When discussing his work, Tàpies frequently alludes to its historical and intellectual context. He is an upholder of the cultural heritage which was revived in the nineteenth century by the Catalan nationalist movement known as the *Renaixença* and which is celebrated in the list of barely legible names in the picture *Inscriptions and Four Lines on Jute* (fig. 56) – names belonging to a culture with which almost nobody outside Spain is familiar. Yet Tàpies also holds back a good deal of information, and sometimes he deliberately leads one astray, especially when the conversation turns to the subject of his secret system of signs.

1 See p. 76.

2 See p. 93.

3 Erhard-Wolfram Platzeck, *Raimund Llull: Sein Leben, seine Werke, die Grundlagen seines Denkens*, Düsseldorf, 1962, vol. 1, p. 247.

4 In his manifestos Breton cites Llull as a Surrealist *avant la lettre*. However, he also notes that 'it remains to be proved that Lully and Berkeley and Hegel and Rabbe [sic] and Baudelaire and Marx and Lenin acted very specially like pigs in the lives they led.' André Breton, *Manifestos of Surrealism*, trans. Richard Seaver and Helen R. Lane, Ann Arbor, 1969, p. 184.

5 Antoni Tàpies, *La pratica de l'art*, Barcelona, 1970; translated here from the German edition, *Praxis der Kunst*, St Gallen, 1976, p. 34.

6 Platzeck, *Lull*, p. 247.

7 Ibid., p. 309. According to Platzeck, Llull's *tabula generalis* contains 1,680 possible combinations.

8 Ibid., p. 312.

9 *Llull-Tàpies*, Paris and Barcelona, 1986.

10 See also p. 106.

11 *Minotaure*, nos. 3 and 4, quoted in Brassaï, *Graffiti*, Stuttgart, Berlin and Zurich, 1960, p. 12 ff. 'Leafing through our collection, the reader will, I believe, have the same experience of surprise as I had when I saw Mexican art in Ménilmontant, the art of the steppes at the Porte des Lilas, pre-Hellenic art in Belleville and the art of the Iroquois Indians in the Latin Quarter. Or when, in other parts of Paris, I discovered a "Picasso", a "Miró", a "Klee". In 1933 I wrote: "The hermaphrodite art of the alleys is taking on the status of a criterion. Its law is binding, and it throws all the cleverly reasoned principles of aesthetics straight out of the window." '

12 Tàpies, *Praxis*, p. 136.

13 The picture contains the following names, phrases and concepts:
 Visca Catalunya: Long live Catalonia.
 Llibertat: Freedom.
 Sant Pere de Rodes (Span., San Pedro de Roda): Romanesque monastery in the Catalan province of Gerona.
 Ramon Llull (b. 1232, Palma/ Majorca – d. 1315/16, Bugia/North Africa): Poet, philosopher, mystic and missionary, founder of the monastery and missionary training college of Miramar on Majorca. Taught at the universities of Paris and Montpellier. His principal work is the *Ars magna*. His extensive oeuvre of philosophical, scientific, theological and mystical treatises was written in a number of languages – Latin, Provençal, Catalan and Arabic – while he wrote his numerous epic and lyric poems mainly in Catalan.
 Trobades: Encounters.
 Oliba: Abbot of the monasteries of Ripoll and Cuixà. An important figure in medieval Catalan history.
 Govern paccionat: Government pact.
 Ripoll: Romanesque monastery at the foot of the Pyrenees in the province of Gerona.
 Arnau de Vilanova (b. 1238/40, Gerona – d. 1311, ditto): Physician, alchemist and poet; wrote in Latin and Catalan.
 Usatge: Former legal system of Catalonia, based on custom and precedent.
 Vicens Ferrer (b. 1350, Valencia – d. 1419, ditto): Theologian, writer and Dominican friar, famous for his sermons written in Catalan. Canonized in 1458.
 Joan Brossa (b. 1919, Barcelona): Catalan writer and artist. In addition to his extensive output as a poet, he has written a number of short pieces for the stage. Tàpies designed the sets for productions of two of these works, which Brossa calls 'scenic poems' (see fig. 46, 48).
 Ausiàs March (b. c. 1397, Gandía – d. 1459, Valencia): Catalan poet, influenced by Provençal literature and the poetry of Petrarch.
 Corts: Catalan parliament, com-

posed of representatives of the various estates.

Humanisme: Humanism.

Jordi de Sant Jordi (c. 1400–1450, Valencia): Poet and chancellor of the exchequer at the court of Alfonso V (the Magnanimous), King of Aragon, Catalonia, Valencia, Majorca and Naples.

Bernat Metge (c. 1350–1410): Catalan writer; translated Petrarch and made his poetry known in Spain.

Riba (Enric Prat de la Riba, 1870–1917): Catalan politician, author of the manifesto *La Nacionalitat Catalana*.

Riba (Carles Riba, 1893–1959): Catalan exponent of *poésie pure*; translated Hölderlin, Poe, Aeschylus, Sophocles, Euripedes and Plutarch into his native language.

Francesc Eiximenis (b. 1327, Gerona – d. 1409, Perpignan): Scholar, poet and Franciscan monk.

Canigó: Site of the monastery of Sant Martí del Canigó in the Pyrenees. This is also the title of an epic poem by Jacint Verdaguer, to which Tàpies may be alluding.

Francesc Marcià (1859–1933): President of Catalonia from 1931 to 1933, following the proclamation of the second Spanish Republic.

Ramón Muntaner (b. 1265, Perelada – d. 1336, Ibiza): Chronicler of the Catalan conquests in Italy, North Africa, Sicily and the eastern Mediterranean. Also wrote poetry in Provençal.

Anselm Turmeda (b. 1352/55, Palma – d. 1423, Tunis): Poet and Franciscan monk, subsequently converted to Islam. Wrote in both Catalan and Arabic.

Josep Puig i Cadafalch (b. 1867, Barcelona – d. 1957, ditto): Architect, art historian and politician. Designed numerous buildings in Barcelona which are now listed as historic monuments. He was also active in the field of town planning and was responsible for the layout of the Plaça de Catalunya. In addition to writing several books about the Romanesque art of Catalonia, he rescued a number of Romanesque frescos from old churches and transferred them into the care of the Museu d'Art de Catalunya.

Bonaventura Carlos Aribau (b. 1798, Barcelona – d. 1862, ditto): Writer, economist and politician. Played a leading role in the revolution of 1820. As a poet, Aribau was the principal initiator of Catalan Romanticism.

Guillem de Bergadà (1138–1196): Troubador at the courts of Richard the Lionheart and, later, Alfonso I. Composed love poetry and chivalric epics.

Joan Maragall (b. 1860, Barcelona – d. 1911, ditto): Catalan poet. Wrote poems, sagas and songs, and translated works by several German writers, including Novalis, Nietzsche and Goethe.

Josep Vicens Foix (b. 1894, Barcelona – d. 1987, ditto): Catalan poet. Editor of the avant-garde review *Trosso* and contributor to the periodical *Monitor*. Arts editor of the magazine *La Publicitat*, 1929–36. Friend of Dalí, Miró, Eluard and Garcia Lorca. Exerted a major influence on the *Dau al Set* group.

Joaquim Rubío i Ors (b. 1818, Barcelona – d. 1899, ditto): Poet of the nineteenth-century Catalan revival movement known as the *Renaixença*.

Jacinto Verdaguer i Santaló (b. 1845, province of Barcelona – d. 1902, ditto): Priest and Catalan poet. With his epic poem *Atlàntida* (1877) he made a decisive contribution to the revival of Catalan as a literary language. His religious poetry is remarkable for its vivid depictions of nature and the inventiveness of its imagery.

Angel Guimera (b. 1849, Santa Cruz/Tenerife – d. 1924, Barcelona): Catalan poet and author of several highly successful Romantic and Naturalist verse dramas. His best-known work, which has been translated into numerous languages, is *Terra Baixa* (Lowland), which formed the basis for Eugen d'Albert's opera *Tiefland*. Like Verdaguer and Maragall, Guimera was, in his time, an extremely popular writer.

Joan Salvat-Papasseit (b. 1894, Barcelona – d. 1924, ditto): Catalan poet. Together with Josep Vicens Foix, he was a member of the Catalan avant-garde which brought new developments in French and Italian literature – especially the work of Apollinaire and the Surrealists – to the attention of the Spanish public.

Antoni Gaudí (b. 1852, Reus – d. 1926, Barcelona): Spanish architect. His most outstanding work – the Sagrada Familia church, the Güell park and the Batlló and Milá houses – was all done in Barcelona.

Lluis Domenech i Montaner (b. 1850,

Barcelona – d. 1923, ditto): Catalan architect, leading exponent of the Art Nouveau style. His designs include the concert hall known as the Palau de la Música Catalana and the building, commissioned by his publisher cousin, which has housed the Antoni Tàpies Foundation since June 1990 (see fig. 52, 99, 100).

 Joan Miró (1893–1983): Painter and sculptor.

 Rafael Casanova (1660–1743): President of the Consell de Cent (Span., Consejo de Ciento) in Barcelona. He was wounded on 11 September 1714 while helping to defend Barcelona against the troops of Philip V. The 11th of September is a national holiday in Catalonia.

 Lluis Companys (1883–1940): Catalan politician, leader of the Catalan parliament. After the death of Marcià, appointed president of the Generalidad. Played an active part in the Catalan resistance movement during the Civil War. Subsequently went into exile in France, but was arrested and executed by the Franco regime in Barcelona in 1940.

14 *The Notebooks of Leonardo da Vinci*, vol. 1, Toronto and London, 1970, p. 254.

15 Account by the Fawkes family of Turner's method of working when painting his *Provisioning Warship First Class*, quoted in Werner Hofmann, *Turner und die Landschaftsmalerei seiner Zeit*, Munich, 1976, p. 24.

16 Roger Corneille, Georges Herrscher and Gaetan Picon, *Der Zeichner Victor Hugo*, Wiesbaden, 1964, p. 13.

17 Joan Brossa, *Frègoli*, with lithographs by Antoni Tàpies, Barcelona, 1969.

18 See Jutta Held, 'Verzicht und Zeremoniell: Zu den Stilleben von Sánchez Cotán und van der Hamen', in *Das Stilleben*, Münster, 1979, p. 380 ff.

19 Sánchez Cotán eventually entered a Carthusian monastery.

20 A. Rodriguez Villa, *Etiquetas de la Casa de Austria*, Madrid, n. d (c. 1885),

p. 9 ff., quoted in Held, 'Verzicht', p. 394.

21 Orozco Diaz, 'El pintor cartujo Sánchez Cotán y el realismo espagnol', *Clavileno* 16, 1952, p. 28, quoted in Held, 'Verzicht', p. 394.

22 'There can be no doubt that the understanding of contradiction ... leads to a reunion with the unconscious laws of life, and the purpose of this reunion is the achievement of living awareness, or, to use the Chinese term, Tao.' Richard Wilhelm and C. G. Jung, *Das Geheimnis der Goldenen Blüte*, Olten and Freiburg, 1971, p. 18, quoted in Chang Chung-Yuan, *Tao, Zen und schöpferische Kraft*, Düsseldorf and Cologne, 1975, p. 8.

23 See Tàpies's comments on this subject on pp. 122, 136.

24 *Or i Sal* (Gold and Salt) by Joan Brossa. Director, Frederic Roda. Premiere on 18 May 1961 at the Palau de la Música Catalana in Barcelona.

 Semimaru by Yuzaki Motokiyo Zeami. Director, Lluís Solà. Premiere on 17 June 1967 at the Teatre de l'Aliança del Poble Nou in Barcelona.

 L'armari en el mar (The Cupboard in the Sea) by Joan Brossa and Josep Maria Mestres Quadreny. Directors, Fabià Puigcerver and Guillem-Jordi Graells. Musical director, Carlos Santos. Premiere on 17 October 1978 at the Teatre Lliure in Barcelona.

 L'Eboulement (The Collapse) by Jacques Dupin. Director, Jacques Guimet. Premiere on 4 February 1982 in the refectory of the University of Paris.

25 In 1985 Miquel Tàpies wrote an essay on his father's stage sets entitled 'Quatre escenografies de Tàpies'. It has remained unpublished.

26 The sculpture does indeed now adorn the roof of the building housing the Foundation, which was opened in June 1990.

27 Mircea Eliade, *Ewige Bilder und Sinnbilder: Über die magisch-religiöse Symbolik*, Frankfurt am Main, 1986.

28 See note 17.

1 *The Scoffer at Diadems*, 1949

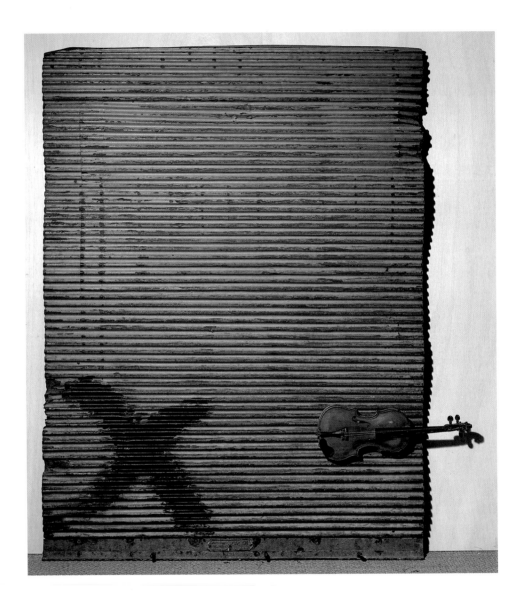

11 *Metal Shutter and Violin*, 1956

III *Black Form on Grey Square*, 1960

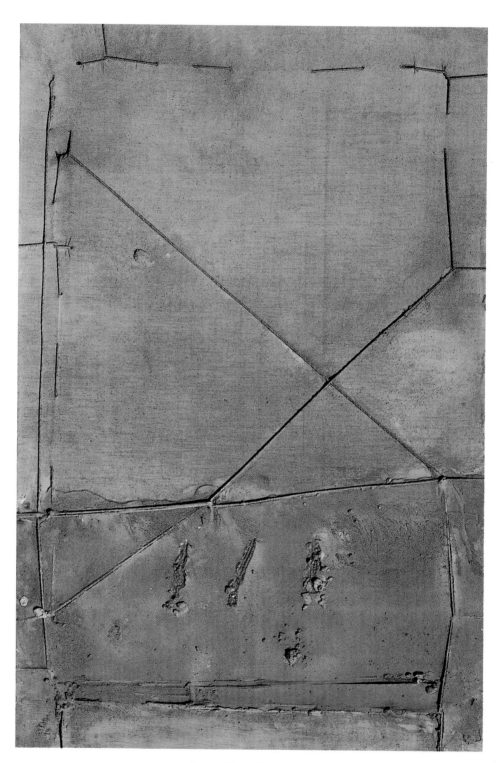

IV *Composition with Strings*, 1963

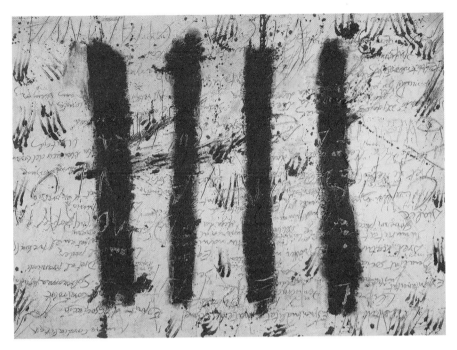

v *The Spirit of Catalonia*, 1971

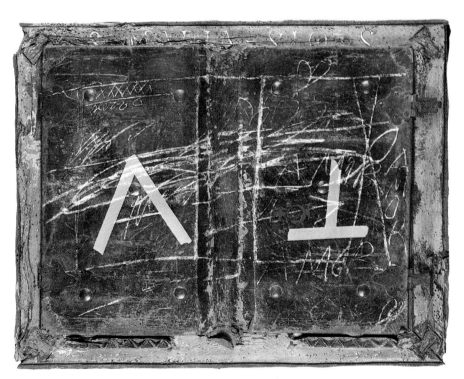

VI *Composition*, 1977/78

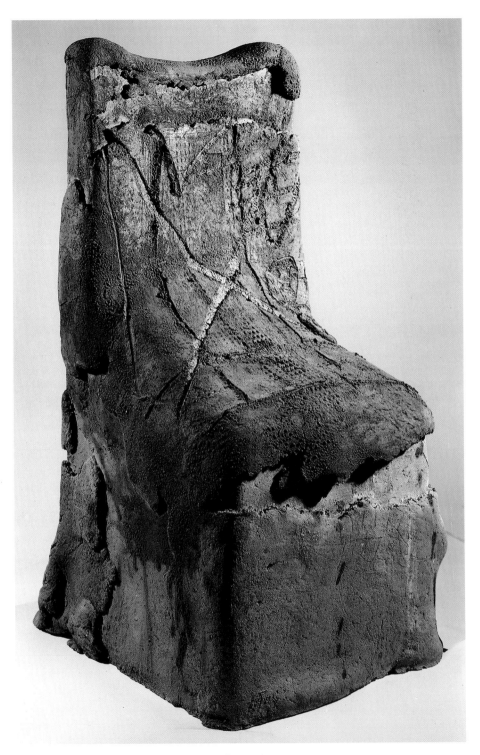

VII *Chair*, 1983

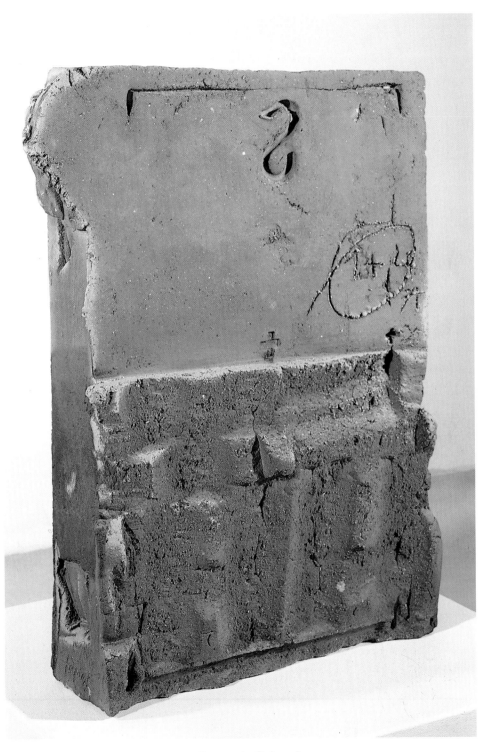

VIII *Rectangular Stela*, 1983

Conversations with Antoni Tàpies

THE ARTIST AND SUCCESS

You are an artist whose work hangs in the world's great museums, you have published your memoirs, and this year [1987] you have announced the establishment of the Antoni Tàpies Foundation. After Picasso and Miró, you will be the third artist to enjoy the public accolade of having a museum in Barcelona devoted to his own work. What does all this mean to you?

Matisse once said that for most artists success, the sense of having reached one's goal, is also a kind of prison. Remembering a story told by the Goncourt brothers, he pointed out that the classic Japanese artists used to change their name several times in the course of their careers, in order to preserve their freedom.

TÀPIES: That's a difficult question to answer because I've never thought about success ... or perhaps I have thought about it without actually using that particular word. I must confess that material success or triumph has never interested me. I don't have a clue about that sort of thing. But there is something else, something which is important to an artist: the achievement of real communication with society after years of struggle.

I myself don't know if I have, in fact, been successful. Perhaps I have enjoyed a *succès d'estime*, but in spiritual terms my success, if it exists at all, has been only very minor. My activities have never had anything to do with the idea of becoming famous or achieving success. I have always been concerned with getting people to listen to me. In everything I do – whether it be arranging exhibitions of my pictures, working on drawings and prints, or looking for a suitable building for the Foundation – my aim is to make people listen. I want to communicate the things that I love and in which I believe, because I think that people can derive a general benefit from them. What I really want is success in a philosophical sense: I want people to grasp something of the ideas and hopes which I express in painting. Of course, there are also my verbal statements. Painting and writing complement each other. But I would like people to learn to read my pictures: that's my reason for founding the museum. However, I don't think that one can speak of my art as successful in the sense of having a mass popular appeal.

Can art ever be popular? Isn't its appeal always limited to a minority audience?

TÀPIES: It is clearly apparent that art, these days, is a minority interest. I find that regrettable. In my country the process of educating people

towards a receptiveness for art, poetry and music is very slow. But that's a matter for the Ministry of Education rather than for the producers of culture. The information one receives about culture is often indigestible. What is lacking is a kind of basic training which starts in childhood. There's no point in simply stimulating the production and consumption of culture in a society which is ill-prepared for it. That leads in the wrong direction entirely: it merely helps to fill the coffers of the culture industry.

You spoke of your art as enjoying a succès d'estime. *Does that not paralyze the reception of your work, which calls for the active participation of the viewer? Is there not a danger that people will accept it without understanding it?*

TAPIES: I don't think the critics are paralyzed. We now have rather more experience of democracy, which means that the range of opinion is broader and that I, too, come in for criticism. For example, my monument to Picasso [see fig. 96] was severely criticized. I was attacked by all the people who regard Dalí, for example, as a Catalan nationalist. I think that the struggle in which my work is involved will continue. This is perhaps less apparent than it used to be, because I now get a certain amount of support from the authorities in Catalonia and the government in Madrid.

But surely this struggle hardly compares with the battles of the past, at the time of the Franco regime? In those days artists and intellectuals faced a continual challenge. Hasn't the intellectual resistance movement lost its edge?

TAPIES: I don't think so, because I have always been convinced that democracy is something you can't just go into a shop and buy. It's something which takes shape gradually and which has to be fought for, just like modern art. It is a project on which we're still working; it's not finished yet. And you must admit that modernism has come under severe attack in recent years, and I, of course, was one of the targets. Lots of people, even the most die-hard conservatives, use the word 'modern', but often it's just a mask that they hide behind, concealing their conservative attitudes. To me it seems that an important element in modernism is the secularization of culture, our achievement of independence as artists from the Church and the monarchy. It's only very gradually that modern culture is breaking down the many barriers and cultural fictions created by reactionary thinkers hiding behind the mask of modernity.

Looking back at your early childhood, what would you say were the crucial events that shaped your subsequent artistic career?

TAPIES: I have often thought about the question of the artist's vocation. Discovering one's vocation is something that can happen gradually, in progressive stages, starting in childhood and continuing at the academy. This I call the 'normal' way. But the discovery can also happen quite suddenly, as a result of unforeseen circumstances. That's how it was with me. The events of the Spanish Civil War made me hyper-sensitive to everything that was going on around me and, as a result of the famine and the general distress caused by the war, I developed tuberculosis. I was bedridden for nearly two years. Consequently, I had a great deal of time to read and think and meditate. I'm sure that my life would have taken a quite different course if I hadn't fallen ill. Astonishingly, the illness didn't sap my mental energies: on the contrary, it was a revelatory experience. I felt stronger than healthy, normal people, and better able to explore reality. I'm convinced that the breathing difficulties resulting from my illness, and the special breathing exercises which I had to do, enabled me to acquire a new spiritual clarity. Years later I read some-

Fig. 53 *Self-Portrait on the Bed*, 1947

where that the breathing exercises used in yoga produce a mental clarity of the kind I had experienced when I was ill. And it was these 'visions' which steered me towards art. I suddenly realized that I could express the same visions through pictures.

Rimbaud said something very similar about the liberation of the artistic impulse through illness. According to him, illness is the route to the 'highest form of knowledge'.

TAPIES: Very good, I like that. I hadn't heard it before. Maybe this heightening of awareness stems from the fact that certain changes in the physical organism help to open up the underlying regions of consciousness.

Were you able to attain this state of heightened sensitivity again when you had recovered from your illness? Is there any other way of achieving the same effect?

TAPIES: When I started painting after all those years of illness, I discovered an exercise which has the effect of sharpening my awareness. For example, I march up and down in my studio at an even pace, snapping my fingers, and if I do this very slowly and for a long time, it generates a nervous tension which, in turn, calls forth a particular vision. The point of this is not to escape from reality but to see it more clearly and penetrate inside it.

You spoke of illness as a 'revelatory' experience. Could you explain what you mean by 'revelation'?

TAPIES: The same thing as in Eastern philosophy: to me revelation means transcending the intellect. One can also find parallels with this in the poetry of Rimbaud and the work of the Surrealists. In addition to the idea of revelation, Rimbaud speaks of the 'alchemy of the word', which I find even more surprising. This points to the obsessive character of his thinking, to his concern with the occult, which is fundamental to avantgarde art and poetry.

You have said on several occasions that you reject the form of institutionalized religious faith represented by the Spanish Catholic Church. But haven't you left a kind of loophole through which Catholicism creeps back into your art – for example, in the guise of a negative theology, in an individual mysticism and in references to the beliefs and religious practices of the common people [see fig. 25, 45, 98]? This is something that I also see in the films of Buñuel.

TAPIES: Yes, I'm sure that's true. I had a strict Catholic upbringing, and at the age of seventeen or eighteen I completely severed all connection with the Church and the beliefs with which I had been indoctrinated. But I have never ceased to be fascinated by the meanings associated with the

etymology of the word 'mysticism'. The term, I believe, derives from the Arabic word *mohesin*,[1] which means inaccessibility, secrecy, darkness – all the things which lie hidden behind the visible face of reality. I have always retained an interest in this kind of mysticism, but not in any religious context [see fig. 22–24].

... as a philosophy, perhaps?

TAPIES: All I'm concerned with is the general mystical sense of which you spoke. I think I shall always retain that. For example, when I broke with Catholicism I began to get very interested in Buddhism, but I never saw myself as a follower of the Buddhist faith.

Do you, nevertheless, see your art as rooted in a mystical tradition?

TAPIES: Yes, and the stronger my sense of affinity with a more or less orthodox tradition of mysticism becomes, the more I believe that the attitude of the great mystics, the whole phenomenon of mysticism, serves as a stimulus to the creative process. The artist himself is a mystical phenomenon. I regard mysticism as a state of mind which is necessary to scientific thinking, as well as to art: it enables one to discover things which cannot be found by any other means.[2]

Do you regard your art as a projection of a spiritual cosmology?

TAPIES: It's a means of communicating with things. I see it as a kind of contact with a universal matter which governs the entire being of the universe and which I think we all, in our own way, resemble. But I don't try to explain this in terms of a superhuman power, a god who created the world. What we see as nature, as 'real', is in fact a very limited notion of reality. I have noticed that, even in the writings of people like Bertrand Russell, whose thinking is highly materialistic, there are passages which speak of mysticism as an instrument that can serve as a stimulus to the work of scientists and materialist thinkers. Mysticism isn't something dark and medieval; on the contrary, I think it can be extremely useful in contemporary life. In the human subconscious there are always certain constants, the symbols which we call archetypes and which recur in all cultures throughout history because they are products of human nature, of the collective unconscious. We are limited by our physical being, and all we can do is to fabricate certain myths which help us to cope with life.

SPONTANEITY AND REFLECTION – SYMBOLS –
THE HUMAN FIGURE

You use the term 'collective unconscious', which was coined by Jung. Do the symbols which continually reappear in your art – the funnel, the V

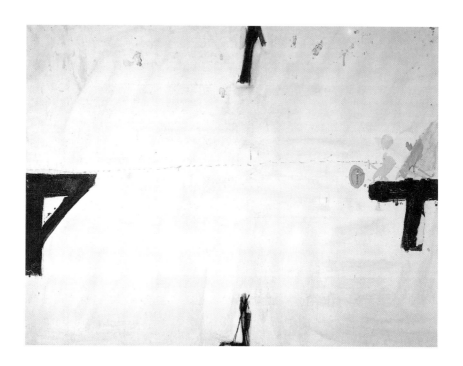

shape, the spiral, the triangle, the cross, the letters X, U, A, T and M – refer to Jungian archetypes, or have you devised your own canon of symbolic images?

TAPIES: I use these symbols spontaneously and intuitively, which gives me a good deal of straightforward pleasure. That sounds terribly simple, and these days it's perhaps somewhat unfashionable to speak of fun as a reason for producing art. But when I'm working I don't analyse my reasons for choosing this or that form, although I could do so after the event. For many years I worked in an almost automatic, unconscious way. It was only when the critics began to question me, as you are doing now, that I made the effort to understand my own work in intellectual terms, to grasp why I had used a particular form or colour in a picture. When I put a sign in a picture, an x or a cross or a spiral, I feel a certain kind of pleasure.[3] I see that the sign gives the picture a particular power, and I don't try to explain why this is the case. The letters, however, have a variety of definite meanings. The letter A stands for the ideas of beginning and limitation. T is both a stylized image of Christ on the cross and the initial letter of my surname, so it's like a meeting of co-ordinates. A and T together can signify the connection either between my Christian name and my surname or between my first name and that of my wife, Teresa.

Are you afraid that analysing your method of working would entail a loss of artistic spontaneity?

74

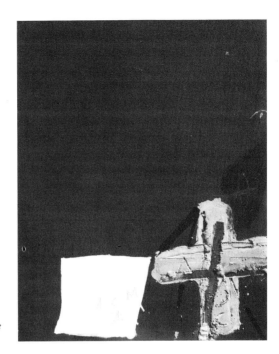

◁ Fig. 54 *White with Black Marks*, 1964

Fig. 55 *Cross, Ochre and White on Brown*, 1971

TAPIES: No, I'm not frightened of losing my spontaneity. What I mean is that I don't want to broadcast my analyses and thoughts all over the place by publishing them. But I do think that one occasionally has to make the effort to analyse one's own work. It's like a 'stop' sign on the road, a chance to reconsider things and recharge your creative batteries. However, I draw a definite line between the spontaneous thoughts which occur to me in the studio and the activity, so fashionable nowadays, of propagating theories about art. Programmatic statements of this kind are often issued by novices, people who have little experience of either art or life. One shouldn't start communicating one's ideas to the public until one has reached the necessary level of maturity.

Does the principle of intuition also apply to your choice of motifs? My question concerns the motifs of the package, the sack, the door and especially the wall – the works which one associates with the idea of closure and confinement [see plates II, III and fig. 30, 31, 56, 57].

TAPIES: That association is probably correct. I'm strongly attracted to motifs which are connected with the occult, with the notion of secrecy, motifs which are difficult to recognize and grasp. But they, too, emerge quite spontaneously: needless to say, I don't use a dictionary of symbols. When I enter the studio I'm still under the influence of the events going on around me in everyday life. Perhaps that's something artists do out of habit: they immediately transform everyday images into pictures.

75

Fig. 56 *Burden*, 1970

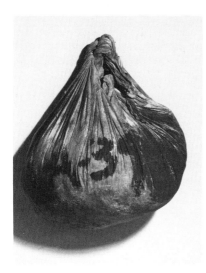

Fig. 57 *Two Blocks*, 1983

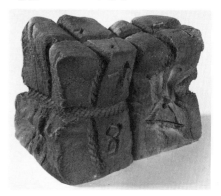

But can't it also be the other way round, that the emotion seeks out the object, and that the objective, the material thing is merely a cipher, standing for a subjective idea?

TAPIES: It's difficult to say. In my view all the questions concerning the opposition between objectivity and subjectivity are a matter of inexactly drawn scholastic distinctions. I believe that in all the things we do or see or analyse the outer and inner worlds are interconnected. So I don't see any kind of barrier or boundary between subjectivity and objectivity: it's impossible to say where the one begins and the other ends. There are a lot of things which we think of as representing external reality, but ultimately they are figments of our own imagination: in other words, what we see as 'objective' is merely a mental construct. Ortega y Gasset once said: 'The word "I" means myself and my circumstances.' But if we were to pursue these questions any further, we'd get entangled in an endless philosophical debate. I think it's extremely important for us to reconsider our stock of knowledge from time to time and to reassess the values connected with it. My wish is that we might progressively lose our confidence in what we think we believe and the things we consider stable and secure, in order to remind ourselves of the infinite number of things still waiting to be discovered.

Apart from in your early pictures you rarely depict the human figure, although you do refer to it indirectly. And even in some of the works from the 1940s and 1950s – the 'icons' and magical pictures [see fig. 20, 24] – the figures are stylized to such a degree that they are really no more than allusions to the human form. Are there philosophical reasons for this?

TAPIES: It certainly had nothing to do with considerations of aesthetic form. Initially, I felt an urge to attack and destroy man's exaggerated

opinion of his own worth, to launch an assault on Western humanism as a whole. I wanted to show that man is not a privileged being, but a part of the universe, that his nature is the same as that of the stars, or of a piece of paper or a leaf. But I don't think it's quite true that there are no depictions of the human figure in my work. For example, many of my pictures include footprints and palmprints [see fig. 33, 60].

Yes, but it seems to me that they are no more than hieroglyphs or signs.

TAPIES: Hieroglyphs – yes, there I have to agree with you. But although the human figure is absent, it is invoked by the signs. Maybe it's all bound up with the fact that I've vowed never to return to photographic, figurative painting. I'm not remotely interested in anything that can be photographed. My aim is to invoke man indirectly through impressions or parts of the human body. Many of my pictures show only an arm, a hand or an armpit [see fig. 61]. I have looked for parts of the human body that are generally considered undignified, in order to demonstrate that all the parts of the body have an equal value.

But the fragmentation of the human body clearly goes way beyond the destruction of the photographic image. In many cases the surface of the canvas, with its thick crust of paint, is perforated, slashed or marked with deep furrows. It's as if you were inflicting deliberate wounds on your pictures.

TAPIES: There's a whole set of intentions involved, as well as a number of ambiguities. On the one hand, it could be that this act of destruction is the expression of an idea which I've always tried to put across in art: the

Fig. 58 *Subject – Object,* 1979

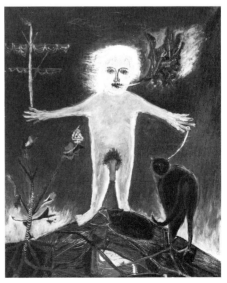

Fig. 59 *Person with Cats,* 1948

77

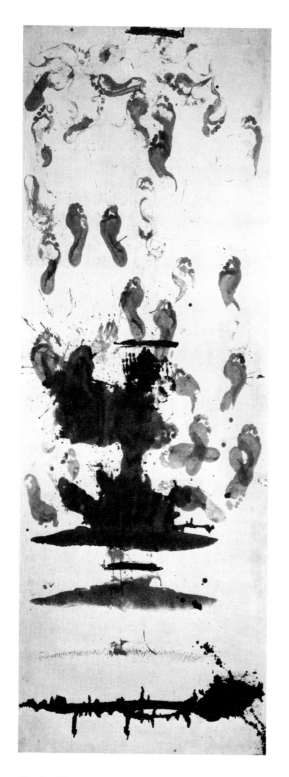

Fig. 60 *Footprints*, 1969

Fig. 61 *Matter in the Form of an Armpit*, 1968

idea that what we call reality is not real at all. When I draw a head, for example, I immediately feel an urge to destroy it, to erase it, because the drawing only captures an outward appearance, and for me the vital issue is what lies behind the visible form of the head. That might be one of the reasons for attacking the canvases. On the other hand, in my work there are also certain symbols of destruction which can't readily be explained because they spring from the subconscious. These are images which we all carry around in our heads. In addition, there is something evocative about the idea of destruction. You only have to think of time-worn, ruined buildings. They emanate a tremendous power which has always been a stimulus to artists. It was ruins which inspired *Guernica* and the epic accounts of the destruction of Troy. Art, especially the art of the Romantic period, is full of ruins, evocations of mortality, of the transitoriness of life And at the same time, all this activates a yearning for 'resurrection', for reconstruction and rebirth. The Buddhists even recommend visiting scenes of destruction and slaughterhouses as important themes for meditation.

Does that explain your preference for things which are old and time-worn?

TAPIES: Oddly enough, that's a question I've never asked myself.

I was thinking in particular of the assemblages, which indicate far more clearly than the pictures that you don't use objects from the present. The items of clothing, the chairs [see fig. 41, 43 and plate VII], the desk heaped with straw [fig. 89], the Iron Shutter with Violin *[plate II], the* Mirror with Confetti *[fig. 91], the basin with the pile of newspapers [fig. 81], the book-*

79

bindings that you use in some of your objects and pictures: these are all things that belong to the past and are worn with use.

TAPIES: This undoubtedly has to do with the fact that I loathe the clean, polished appearance of machine-made objects. I can't say why, because I don't know. Perhaps because old things are imbued with traces of humanity. The products of industry, of design, have lost all the spiritual functions which are essential to human life. Designers only think of the material uses of things: if they are making a chair, for example, the only question that interests them is whether it's comfortable to sit on, ignoring the fact that it also has a spiritual function to fulfil. The crucial issue here is probably that of materials. Chrome, glass and plastic are lacking in tactile qualities, the qualities we can touch or feel with our hands and eyes. They have no aura because, unlike wood, they are inorganic and artificial. This, to me, is a massive limitation. A simple craftsman or folk-artist, using his hands, makes far more beautiful objects than someone who has studied art.

Let me come back to the question of destructiveness. Isn't this destructive impulse also directed against the work of art as such, against your own work?

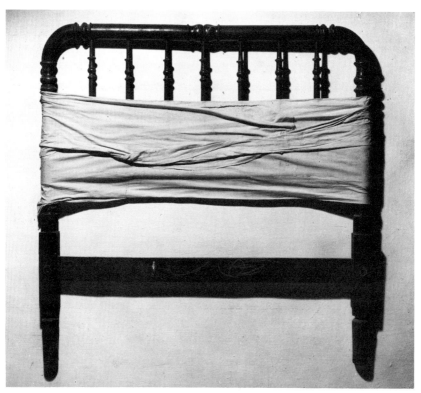

Fig. 62 *Bedstead with Sheet*, 1973

TAPIES: Yes, that's right. It would seem that artists are always fighting the establishment, opposing the officially accepted forms of art. In the twentieth century the Dadaists have demonstrated this in an openly programmatic way. Think, for example, of Miró's famous remark: 'Painting has to be murdered'. But this urge to destroy is ultimately the motive force which animates and transforms everything. In addition, I think that every artist has to struggle against complacency: if he is satisfied with his own work he will find himself entrapped in his own private system, in a new aesthetic which binds and constricts him. I believe that artists should always be against aesthetics on principle. Artists go through periodic crises in which they feel an urge to destroy themselves. This is important, because if we succeed in mastering the crisis we rise again, as if reborn, from our own ashes.

In 1954/55 you began to create the stark impasto paintings, using various tools to modify the thick surface [see fig. 30, 31]. At the same time, the colours ceased to glow. Was this the direct result of such a crisis?

TAPIES: I went through a major crisis after my second one-man exhibition [in 1952]. I felt repelled by both of the movements which dominated the art scene at the time: by social realism on the one hand, and, on the other, by the abstract and concrete art which was particularly associated with the *L'Art Aujourd'hui* group in Paris. I wanted to start again from scratch, and I plunged headlong into experimentation, doing work that was experimental in a spiritual as well as a formal sense. Looking for new spiritual models, I read a great deal about Eastern philosophies: the Vedanta, yoga, Taoism and Zen. My pictures became veritable experimental battlefields. I worked like a madman, endlessly trying to adapt new materials. Eventually, this destruction in quantitative terms led to a qualitative transformation. Destruction was succeeded by stasis and calm. A sense of synthesis or union even became apparent in the colours: I started to paint grey pictures [see fig. 31].

THE INFLUENCE OF EASTERN PHILOSOPHIES

You frequently refer to Eastern philosophies, religions and attitudes. When did you first become interested in Oriental thinking?

TAPIES: My interest in the subject was first aroused by a book called *The Little Book of Tea*, by Kazoko Okakura,[4] which I read as a child. As an introduction to the world of the East I still consider it unsurpassed. It contains a Taoist fable about a harp which only one person was able to play. The story is an object lesson in aesthetics and the philosophy of life, speaking of the mutual state of receptiveness which is essential to the

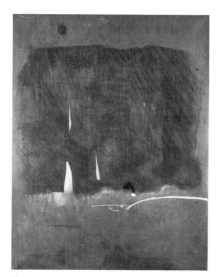
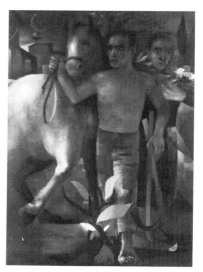

Fig. 63 *Evening*, 1954/55 Fig. 64 *Couple and Horse*, 1951

understanding of art. The viewer has to cultivate the right attitude in order to get the message, and the artist has to know how to put the message across. In addition, the fable exemplifies and explains the cosmological principles of Yin and Yang, on which the whole of nature rests. These principles have also exerted a strong influence on Western ideologies. Leibniz, for example, studied the Chinese writings that had been translated by the Jesuits. Hegel was familiar with the *I Ching* and the *Tao Te Ching*,[5] which even left their mark on the dialectical materialism of Marx, not to mention Mao – I'm convinced that he continued to consult the *I Ching*, the Book of Changes. It's also well known that Schopenhauer studied the ideas of Eastern thinkers.

The idea of art as a *tek'an*, a form of gnosis, a path (or Tao) of knowledge, is fundamental to my work and to that of many other artists since the Romantic period: it was embraced by Rimbaud, for example, and later by the Surrealists. There are even a number of young artists who cite the teachings of Taoist philosophy: for example, the group of writers and artists formerly associated with the magazine *Tel Quel* in Paris.

Which of these philosophies has influenced you most?

TAPIES: The greatest influence has been that of Zen, which combines the best elements of Taoism and Buddhism. When I started out as an artist Zen helped me to find my bearings in contemporary art and literature. Later I got to know the Orient better, via the numerous translations of classical texts which were impossible to get hold of when I was young. I believe that the contribution of the Orient has been crucial not only to my art, but to the development of Western culture as a whole. In my view the truly path-breaking cultural achievements of our century have come

Fig. 65 *Calligraphy*, 1978

from people who recognized the need to reinterpret and rediscover our culture. They were able to avert the cultural catastrophe threatening the West, a catastrophe stemming, as Alan Watts once said,[6] from the tendency of the Occident to close in on itself and lose all receptiveness to the potential contained in the wisdom of other cultures. There is still a grand conspiracy to withhold from us the profound, non-dualist insight encapsulated in the Sanskrit saying *tat tvam asi* (you are that), meaning that the *atman* (the self or soul) is identical with the Brahman. In the West this is still seen as a terrible sin, an example of Oriental arrogance: it serves as a pretext for people to soothe their consciences and justify all the inequalities and injustices of our Catholic, Western world.

WHAT I SEEK TO ACHIEVE WITH MY ART

Matisse strove for an art of balance. He wanted people to be able to relax in front of his pictures, as if they were sitting in an easy chair. What do you aim to achieve with your work?

TÀPIES: Surely the very opposite. But I don't know if one can really take that statement by Matisse literally. There are a lot of his pictures which I love: I see them as a kind of heathen anthem to nature. However, I refuse to see them as having a relaxing effect, as works you can look at resting in an armchair, as if you'd just eaten a sumptuous meal. I think that works of art should startle the viewer into thinking about the meaning of life. We are all aware that people are growing more and more alienated as a result of advertising, publicity and the consumerism which is foisted on us by the mass media. I believe that art is one of the last oases of freedom, and that it still has the capacity to make people think. Most people's notion of normal life bears no relation to real life: it's part of a system of life which has been thrust upon them.

How does your intention of startling the viewer square with the Buddhist desire for meditative tranquillity, rejecting the material world? How do you reconcile provocation with contemplation?

TÀPIES: There is a meditative side to Zen, but there's also the element of shock, rocking the foundations of thought and making things indigestible rather than digestible. There are moments when I immerse myself in contemplation and completely dissolve myself in nothingness. But then there are the moments when I try, in a different way, to suggest the idea of nothingness and thereby give the viewer a jolt.

Since the signs in your works are open to individual interpretation, the question arises whether you really give the viewer complete freedom to interpret them in any way he chooses, or whether you believe that you

guide him towards the 'correct' way of seeing, precisely by leaving so much scope for free association. An example which occurs to me is that of Nathalie Sarraute, whose aim is to draw the reader into the territory of the writer, where the absence of familiar landmarks has a disorientating effect.

TAPIES: My work can indeed be read in several different ways. By giving things a purely allusive character, one creates far more scope for the associations that I want to trigger off in the viewer. I didn't analyse this at all when I started out, but for some time now I have been studying the art of the Far East, in which ambiguity plays a very important part. I've noticed that, if one draws things in a manner which provides only the barest clue to their meaning, the viewer is forced to fill in the gaps by using his own imagination. He is compelled to participate in the creative act, which I consider very important. As a result, he finds himself directly confronted with the problems of the artist. In Chinese painting, where a tree, for example, is often represented by a small drawing of a twig in one corner, or at the edge, of the picture, surrounded by blank space, the viewer is obliged to reconstruct the whole tree and, with it, the process of natural growth, seeing the power of nature in relation to the entire cosmos.

Isn't this idea of inducing people to see things, of drawing them into the picture, also connected with a desire to overpower the viewer?

TAPIES: Yes, that's certainly what the artist wants to do: to grab the viewer by the scruff of the neck, to overwhelm him and involve him in a specific way which one thinks might be important.

Is there a particular maxim that you live by?

TAPIES: I don't have a specific maxim. But since you ask, I suppose a possible answer to your question might be 'Know thyself'. I've always been far more concerned with the search for inner perfection than with my development as a painter. And this process of self-education leads to a higher level of awareness. Knowledge and love, the things that the great men of wisdom preach, can be found only by the individual, through introspection, which requires tremendous effort. The same applies to art. Art really can have an educative effect, but it's only a door which leads, in turn, to a further door. Ultimately, it's the viewer who has to make this effort of introspection. Art is only an aid, maybe an aid for the artist himself.

In your work of the last few years the skull has been a recurrent motif [see fig. 66].

TAPIES: Yes, it crops up a lot. But I don't know if it's a recent thing. I've been concerned with the subjects of death and pain for a long time, and there are allusions to these things in my earlier work. A possible reason for this is that I once came very close to dying.

After your operation?

TAPIES: No, I was nearer to death when I had my first bout of heart trouble at the age of eighteen. But at my present age I naturally devote more thought to death. There was the influence of Buddhism, too. The Buddhist monks instruct their pupils to think about death and even tell them to visit places where death is present, such as slaughterhouses and graveyards.

Christianity also teaches us to consider the subject of death.

TAPIES: Yes, of course, that's an idea one also finds in the West. In the history of art there's a whole tradition of interest in death: the dance of death, the theme of *vanitas*...

You mentioned graveyards and slaughterhouses. Isn't the bull-ring also a place of death? Do you go to bullfights?

Fig. 66 *Skull*, 1985/86

TAPIES: My attitude to bullfighting is extremely negative [see fig. 68]. These days it's totally commercialized, and it plays on the basest human instincts. I find it intolerable that such a noble creature should be tormented and slowly put to death, so it's out of the question for me to take any interest in the subject.

THE ARTIST AT WORK

Your house is completely screened off from the street: all that can be seen from outside is a seemingly blank wall, interrupted only by rows of shutters [see fig. 1]. Its appearance is pointedly off-putting. Do you see art as something which can only be created in total seclusion?

 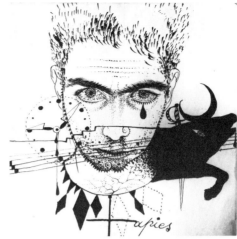

Fig. 67 *Head with Two Crosses*, 1985 Fig. 68 *Self-Portrait*, 1950

TAPIES: I think that a certain measure of solitude is necessary if one is bent on doing something really creative. But that doesn't entail severing all connection with the outside world. The creative act requires the artist to retreat into his studio, just as scientists shut themselves away in the laboratory. In this respect, artists and scientists have a good deal in common. Individual decisions are very important in one's work, although that doesn't mean that the individualist has to be anti-social.

You paint only in closed rooms [see fig. 104]. What importance does nature have for you?

TAPIES: In locking myself away in my studio, my aim is to find the peace and quiet which are necessary for concentration; I'm not trying to cut myself off from nature. When I'm staying at our house in the country [in Campins] I greatly enjoy walking in the mountains. In fact, I seek as much contact with nature as possible. I think that the extent of my happiness is determined by my gradual success in attaining an understanding of what nature can mean. At the same time, I also feel an increasing sense of attachment to other people.

It's only when I'm working in the studio that I have to shut all the windows. The studio in Campins has windows, for example, and I've blacked them out. I find the view outside distracting.

Does the atmosphere of the room play a part in your work? Can the room have a stimulating effect?

TAPIES: Yes, I think it can, and I'm sure that's the case with all artists. We're heavily dependent on the mood of our surroundings. But, at the same time, we try to change it: we want to create an alternative reality, not just through art, but via everything around us. In my studio I try to

create an atmosphere, a mood, a climate which has a positive effect on my imagination. I endeavour to establish a certain spiritual 'temperature'. I assimilate my surroundings into my art in a way which also relates to the eventual viewer of the work. I'm fully aware that the surroundings play an important part as a stimulus in summoning forth the ideas or visions of the new reality that one wants to create.

Do your other surroundings, outside the studio, also act as a stimulus?

TÀPIES: It's not just a question of the studio. I also feel the need to have a say in the design and furnishing of the house we live in. I don't do this in a very deliberate way, following any kind of definite principle, but I think that, over the years, we've nevertheless managed to create a certain atmosphere. The same thing happens when I find myself faced with an empty studio. I immediately have to do something to fill the void, because if the studio is empty it feels as though I were starting again from scratch. In order to make or to build something new, I need a basis, something that's ready-made. In other words, I have to create a particular climate.

Does this also apply to the empty canvas?

TÀPIES: Yes, it's just the same. When I start work on a picture I feel quite lost at first. Other painters have told me that they have the same experience. One wanders up and down in front of the canvas for hours on end, because sullying the pure white surface seems like an act of sacrilege.

Do you always know when a picture is finished?

TÀPIES: No, that's a major problem for artists – knowing when to stop. Sometimes I see everything quite clearly, and I stop, but then there are other occasions when I carry on working and make mistakes. I insist on continuing and either mess up the picture altogether or succeed in improving it. In general, I act as if I myself were the viewer: I look at the picture very closely. Before finishing a work, I put it aside for two or three days, and then I look at it again, as if I were the first person ever to see it. This enables me to recognize the things that I like or dislike.

Do you paint very quickly?

TÀPIES: On the whole, yes. Painting quickly is a calculated act to block out rational thought. And as you know, I use quick-drying paints: enamel paint, for example. This means that one has to paint fast, otherwise the colour will dry and become impossible to work with. But I deliberately seek out problems of this kind: I welcome the challenge which they pose. When I'm working in a hurry the effort of concentration is accompanied by an anxiety which also stimulates my imagination. For example, it often happens that I'm in the studio and I've been trying all morning to work: I've prepared all my materials, but nothing has happened, things

just won't click. I know it's getting on for two o'clock and Teresa will soon be calling me to lunch, so I've got only half an hour left. I'm working against the clock, and then, suddenly, the moment arrives – the moment of revelation, when I'm physically tired at the end of a morning or a day. Physical tiredness also has a stimulating effect.

It's a stimulus in writing, too ... Can you see the work in your mind's eye before you start?

TAPIES: Sometimes, yes. I have a mental image of it. And occasionally I wake up in the night and see a picture in front of me. I do a quick sketch to jog my memory when I'm back in the studio, because sometimes I've had ideas of this kind and completely forgotten them. So I jot the idea down. Sometimes it works and sometimes it doesn't: it's not always possible to translate things one has imagined into pictures. The first thing one has to do is to engage in a dialogue with the materials: they speak, they have a language of their own, and from this the dialogue develops between the artist and his materials. One often has to discard ideas because they conflict with the materials. Then a kind of struggle begins between the idea which I'm trying to express and the material form that I want to give it. If the idea is too insubstantial, too elementary or superficial, the pictures start to protest. If this happens I add something or cross things out and destroy the colour. The changes are dictated by the picture itself. Hence my method of working becomes an inescapable dialogue between the original idea, arising from everyday feelings, and the material of the canvas.

In a French television programme about you I saw something that puzzled me: you were shown expanding a small picture into a large one. I'd never seen you do that before. Is that your normal way of working, or was it just staged for the camera? It must be impossible for an artist to concentrate when he's being filmed.

TAPIES: In the first instance, of course, it was for television, but it was also partly because of the large canvas. If a picture is very big I have to start with a small sketch. I don't know if that was apparent in the programme – it was just a little rough drawing.

No, I couldn't see that. I was quite alarmed, because repetition is out of the question in an art which relies so heavily on spontaneity.

TAPIES: Yes, but as I explained, I sometimes do an outline sketch to get an idea of the picture as a whole. The picture which I painted during the filming of the programme consisted mainly of a shape representing a large knot. If a camera crew is coming, I have to know in advance what I'm going to paint. I have to prepare the picture, although obviously I can't anticipate all the details and the things that are going to happen by chance.

Fig. 69 *Graffiti, Red,* 1985

The Zen masters are in the habit of repeating a movement of the brush as many as a hundred times in order to get as close as possible to what they want to express. Have you tried this as well?

TAPIES: It's difficult to draw comparisons, because Oriental artists – especially the Zen masters – generally have stock themes which they use over and over again: the circle, the triangle, Hotei with his sack, or Mount Fuji.

I was thinking of certain kinds of abstract painting – the work of Robert Motherwell, for example, who did a series of paintings repeating the same image up to a hundred times, in a manner reminiscent of academic exercises.

TAPIES: No, I've never done that.

Sometimes you apply the paint with your feet and the flat of your hand. The Buddhist monks even used to create pictures by spitting ink on to the paper. Have you ever done anything of that kind?

TAPIES: Yes, they filled their mouths with ink and spat it out over the paper. I don't find that terribly interesting. It's a game of chance, but you can play games of that kind in other ways without having to get your mouth all inky. The result is the same as if you use ink diluted with a lot of water. I thought that even Yves Klein took this sort of thing too far. He made pictures with flame-throwers. It's all highly spectacular, but the result remains trivial.

Do you destroy works that you consider failures?

TAPIES: If a thing goes wrong I change it, but I don't destroy it. For example, if I'm using black paint and I make a gesture with the brush that I don't like, I re-prime the canvas in black and put it aside for later reference. Sometimes I correct a wrong gesture a few days later when I've found a solution to the problem, a way of changing the picture by adding a further sign or a minor detail. There are times when I sense at the very first brushstroke that the picture is going to misfire. The moment I mark the white canvas, I immediately think: 'You've got to correct that.' All my pictures are a kind of revision of my original ideal. This is surely very different from the way in which Japanese or Chinese artists work: their themes are pre-ordained, whereas mine are invented at will.

Some of your works are highly dramatic, based on the open, wild, chaotic gesture, while others radiate calm and tranquillity, with hermetically closed, mainly symmetrical forms. Is it possible to paint pictures of both kinds on one and the same day, or do these two different approaches represent separate phases in your work?

TAPIES: My pictures, with which I surround myself in my studio, standing them up against the walls, are a kind of musical composition. I always look at the composition as a whole to see what is missing: perhaps, for example, I feel that I need a more lively picture. The works are like the individual movements of a symphony. I try to create a particular atmosphere with them. To do this, I need different movements or tempi: passages which are slow and quiet, and others which are light and brisk. I often work on the principle of contrast, and I'm not satisfied until I have a whole series of pictures grouped round me in the studio. This is also a form of revision, correcting the picture in the context of the group.

A way of evening things out, of finding a point of balance?

TAPIES: Or perhaps of finding a point of contact.

I remember that, in one of your big exhibitions, all the vehement, anarchistic paintings and the pictures which demonstrate your commitment to the Catalan cause were left out.

TAPIES: By selecting certain pictures and omitting others, it's possible to make my work mean something quite different.

Are there any particular pictures which you regard as key works?

TAPIES: You mean works which mark an important point in a certain phase of development? Yes, I think there probably are. During my Surrealist phase, in the days of the *Dau al Set* group, there was the moment when I rediscovered interior painting. In the work of Miró, for example, the subject was always the outside world – landscape, the cosmos. But what interested me was the interior. I was concerned with things that were closed and with furniture. There are several important pictures from my Surrealist period in which I think this emphasis is clearly apparent [see fig. 3]. And then, from the phase when I was exhibiting with Michel Tapié at the Galerie Stadler, there are a number of paintings which show how I discovered the wall as a theme [see fig. 30, 31]. I think one could point to three or four major works, although I could be wrong, of course: that's always a possibility. A piece of paper or a little sketch can also be a key work. The big pictures are important to the art historians and the museums, but in my work the small things are often more significant; even things which came about by chance rather than as a result of some grand intention – things that gave me ideas for other works.

MADNESS – DREAMS – PSYCHOANALYSIS

In Barcelona there was a group of artists who met regularly at the house of the photographer Leopoldo Pomès, where they played a kind of parlour game which involved each member of the group doing an impersonation of himself. The role which you chose to play was that of a lunatic, raving and babbling. Does madness hold a particular fascination for you, even if it's only a fascination which is motivated by fear?

TAPIES: I'm not entirely sure what my motives are. But it's true that I'm fascinated by mental illness. Sometimes I think that it stems from an experience in my childhood. My grandfather was the president of the patron's committee of a hospital in Barcelona – an ordinary hospital, not a psychiatric clinic. But he also had to visit other hospitals, and one day he took me with him to a lunatic asylum. It gave me a real shock, and I was terribly upset. I was still very young: ten, eleven, maybe twelve years old. As an adult, however, I realized that madness isn't just an illness: it can also uncover areas of thinking which are normally shrouded in darkness. And this fascination has a certain amount to do with belief, with a belief in the secret things that go on in the minds of the mad. Artists are magnetically attracted to the heretical aspects of religion, the rites and ceremonies, everything beyond the realm of the 'normal'. This fascination is also rooted in the history of art. Like all contemporary artists, I've

been heavily influenced by Dada and Surrealism, which were based entirely on the abnormal, on diabolism, dreams and the whole ideology of Freudianism. Having read some of the literature of psychoanalysis, especially the writings of C. G. Jung, I came to the conclusion that the myths which are openly expressed in mental illness are part of the archetypes which underlie human nature but which we generally keep hidden. When mental patients produce interesting works of art they express themselves, like artists, in terms of myth. This is also the reason why, to me, these pictures seem totally familiar. I know a number of psychiatrists who have shown me pictures by madmen. They expected me to be shocked, but I wasn't.

Do you see mental illness as an extension of the artistic imagination, like the Surrealists, who even tried to simulate madness in order to experience and depict it, as something which is always latent in the human mind?

TAPIES: Not as an extension. But madmen, like artists, have a heightened sensibility which enables them to discover elemental myths. The phenomenon of madness is also interesting as a means of explaining the workings of the artist's unconscious. However, this kind of illness is also very limiting: it prevents these people from becoming real artists. One can see this, for example, in the work of Antonin Artaud. Although he had moments of brilliance, moments of true inspiration, some of his writings clearly show that he was deranged.

Have you ever worked under the influence of drugs?

TAPIES: No, never. I'm sure it's an interesting thing to do, as long as it's purely an experiment and one is able to draw on the memory of the experience, which may benefit one's painting. But, of course, one should never work under the immediate influence of drugs. When I had my first heart attack at the age of eighteen I had a very strange experience of heightened awareness. This, I imagine, might be comparable with the visions induced by drugs. However, I myself have never really experimented with drugs. They frighten me. I'm scared of anything that I can't control. I don't want to become the sorcerer's apprentice.

A fear of the id?

TAPIES: A fear of not being able to turn back, of never returning.

THE PORTRAIT

I saw in your archives that, during the first ten years of your career, up to 1954, you painted and drew a large number of portraits and even self-portraits [see fig. 21–23, 53, 68, 70–73].

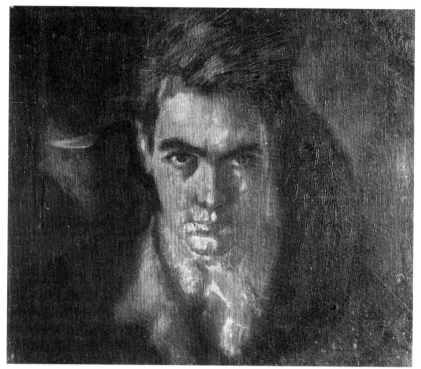

Fig. 70 *Self-Portrait*, 1952

TAPIES: Yes, that's right. I did a lot of portraits.

And very few of them are at all known. You've largely withheld them from the public. There's only a handful of reproductions in the monographs on your work, and an even smaller number of portraits have been exhibited.

TAPIES: That's true, but there will be reproductions of all of them in the *catalogue raisonnée* which we're currently putting together.[7] Of course, there are also a number of portraits which I only did to earn money or as academic exercises. I don't like them, and they won't be in the catalogue. I'm also leaving out the purely academic studies which I did as a student. However, there are also a fair number of portraits which I think are quite attractive. Some of the others are pointedly ugly, painted in a style which is a bit like *Neue Sachlichkeit*, the German school of Magic Realism with a critical message. I shall be including them in the first volume, which covers the initial phase of my artistic development, up to 1960. After that, there will be three further volumes, each about 500 pages long.[8]

When I looked at the photographs of these early pictures I realized that, at the time when I was working on them, I was heavily influenced by Matisse [see fig. 71]. I'd never noticed this before. It was only recently, when I was going through all these photographs, that it struck me for the first time. I was forced to admit that in quite a number of my early drawings the influence of Matisse is clearly apparent.

In the clear line, the absence of three-dimensional illusion.

TAPIES: Young people are seekers, and sometimes they are influenced by things without being aware of the fact. It happens more or less subconsciously. I remember that one of the first books I ever bought was a book on Matisse's drawings.

What about his painting? Were you ever fascinated by that, too?

TAPIES: Matisse is more of a painter. He's what you might call a Mediterranean artist, a sensualist. His work is directed outwards, whereas I was interested in other things. I'm gloomier, less sensual, more inward-looking.

LIGHT AND COLOUR

The pictures which you painted in 1948/49 are light and transparent. In your most recent work one finds a similar lightness, transparency and fluidity. Has light ever been an important theme in your painting?

TAPIES: It's not a theme I've been aware of, apart from in the pictures which I did in 1948 and 1949, where I was responding sensuously to light rather than colour. I kept the background very dark and put in an illuminated space, a kind of opening, like a church window. The oil paint created a phosphorescent effect.

I have sometimes wondered about the importance of colour in your painting, asking myself whether, in a painterly sense, it plays any part at all in your work.

TAPIES: Yes, it's odd: I have an almost manic aversion to colour, to the primary colours – red, yellow, green and blue – because the world around us is so full of them. I think advertising has given us a surfeit of colour. I'm positively allergic to colour. But no doubt there are plenty of other good reasons – which have less to do with form – for being anti-colourist.

Has colour been supplanted by a fascination with materials?

TAPIES: I want to be in touch with a reality which lies beneath the surface of things. I've looked for colours which are more ... I don't know, it's hard to explain, because these are things that can't be put into words, things which are almost like visions or mystical revelations. It's the colour beneath the superficial appearance of reality, the colour of dream and fantasy, the colour of visions, the colour of emptiness, the colour of space.

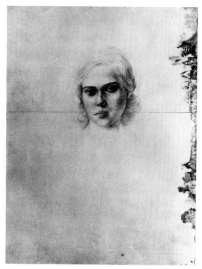

Fig. 71 *Portrait*, 1946

Fig. 72 *Teresa*, 1951

CHAOS AND ORDER

What are your preferences in art?

TAPIES: On the whole, I'm attracted to artists in whose work I find con-
nections between art and religion, revealing a spiritual idea or deep
insight. For example, I have a great fondness for the art of the Far East,
especially the art of the Chan sect[9] and of the Zen masters. The stronger
the artist's identification with a particular conviction [*pensée*], the more
successful his work becomes. I could say that, in a certain sense, my roots
lie in religious art as a whole: the art of Egypt, China and India, and, in
my own country, Romanesque art, the tenebrism of the seventeenth
century and the work of Gaudí. A number of Surrealist artists also took
an interest in religion and magic. That's another reason why I have a
preference for this kind of art.

*You said that you create symbols in a purely intuitive way. Whereas religi-
ous art, of whatever kind, is based on a fixed canon of symbols, the mean-
ing of the signs in your work is indeterminate: like an alchemist, you use
combinations of symbols with hidden connotations.*

TAPIES: You're right: there's no immediate connection between my work
and the dogmatic forms of religious art. However, the religious
phenomenon I'm talking about has very little to do with official religions.
My personal god[10] is not to be found in heaven but on earth, as in the
wisdom of the Orient. It's possible to define the idea of religiosity in more
general terms, following the example of Rudolf Otto.[11] Bearing this in

mind, I frequently refer to religions which have a less religious character, such as Chan or Zen, 'wisdom', Chinese humanism, Vedanta[12] and yoga:[13] the least dogmatic, or even atheistic, brands of religion. My painting is not an illustration of a particular set of religious beliefs. It claims to be a technique, like yoga, the *koan*[14] or the Buddhist *kasinas*,[15] an aid to meditation and enlightenment. As we said earlier on, there are parallels between all these things and the attitude of the mystic or the alchemist. If we define alchemy in a very broad sense as the science of the essential and its causes, then we can understand why artists use it as a means of expressing the unnameable and of resolving contradictions. But for me it's not a ritual or a symbolic canon. The spiritual uncovers myths which belong to the human soul: they're not the private property of religions. As Jung said, it wasn't the man Jesus who created the myth of the god of men: the myth existed long before Jesus was born. The gods

Fig. 73 *Self-Portrait*, 1950

descended from Olympus and installed themselves in our solar plexus. The gods no longer reside in heaven: on the contrary, they were created by the problems and conflicts of our individual and collective soul which manifest themselves in religions, and they still remain within us. I believe that god and many religious symbols are nothing more than human projections. And artists, like poets and philosophers, can help to depict them.

What are your preferences in European art, the ones which perhaps influenced your development?

TAPIES: In contemporary art I favour the painting of the Surrealist artists who, like me, look for spiritual and magical things in art. Miró, Paul Klee and Max Ernst are some of the examples which spring to mind. And this inclination towards the spiritual and the magical can be traced back in time: I like Romanesque art, for example, and I reject the art of the Renaissance, because I reject any kind of classical style. Even Raphael, for all his fame, is too conventional for my taste. In certain eighteenth-century rationalist paintings one can see the very antithesis of my approach to art. It wasn't until the Romantic period that the movement towards the irrational and the obscure re-established itself.

Does your rejection of classicism apply to the whole of Greek and Roman art, and hence to Greek philosophy as well?

TAPIES: No, not at all. I even find pre-Socratic philosophy, or what I know of it, very interesting: Heraclitus and Parmenides were philosophers who pictured the cosmos as a whole. It's often almost dialectical, and I also detect parallels with Eastern philosophy and mysticism. There are some Greek philosophers I really like. When I comment on classicism so vehemently, and when I make fun of it, the main target of my attacks is the customary reverence for Greece, for Greek and Roman sculpture, together with all the stuff they teach at the academies, which goes back to Raphael. But this is more a general feeling than a specific philosophy. What I'm also trying to say is that the whole strand of culture which was shaped by classicism – the style of the Vatican, for example – has dominated the European mentality for centuries. I find this inadequate: it leaves out the complementary, enriching potential of civilizations in other parts of the world.

For centuries space was seen as a hollow cavity, inside which there were separate bodies, marionettes, which were manipulated by a supernatural being. I believe that we now have a knowledge of space which is completely different. The idea of separate bodies created a kind of antagonism between you and me, and it was also used to construct oppositions between man and nature. This played a crucial part in the making of the European mentality: we fight against nature and against one another. But the modern concept of space is closely akin to Eastern ideas. Between you and me there are magnetic fields and electrical impulses, things one can't see but which nevertheless exist and unite us with each other – and with nature, too.

Modern atomic physics has given us new concepts of time and space, just as the new psychology has enhanced our understanding of the human mind, and it seems to me that a rapprochement is taking place between these ideas and the thinking of some of the Indian and Chinese

philosophers. The system of the Vatican, on the other hand, is slanted towards Aristotle rather than Plato.

The language of classicism, of the classical sciences, was extremely useful in furthering communication between people, in technological development and everyday life. But it's not suited to the task of expressing a deeper reality, which can't be explained in ordinary language. Even scientists have to resort to formulae. Words cannot convey this ultimate truth or reality. These two viewpoints are complementary.

Classicism is generally associated with the principles of order and rationality, and anti-classical art with those of disorder and irrationality. Claudel once said that order was the 'pleasure of reason', but he extolled disorder as the 'ecstasy of the imagination'. What do the ideas of order and disorder mean to you?

TAPIES: As with all antagonisms, the one always calls forth the other: the colour white, for example, invariably conjures up black. I think there's always a need for these opposing forces. Acting together, the two antipodes are the motive power, the engine, of history. It always starts with disorder and rebellion: they supply the initial spark. To this extent the avant-garde always stands for a certain measure of disorder. Reason, on the other hand, is the cylinder, while disorder is the piston or the sparking-plug. But referring again to the classical and romantic movements, I think these are just aspects or facets of a whole which constitutes the human mind. Both sides are present in every artist and every human being. For my own part, I think I tend rather to look for balance. It's the piston which really drives the engine. Classification, of whatever kind, always constricts the artist and his work, and, in general, artists don't want to be constricted.

In your memoirs[16] you mention three artists who were important to yourself and your work: Miró, Picasso and Klee. You say that Miró was the greatest painter of his generation, not only in Spain but in the world. Did he affect you more than Picasso, an artist who continually renewed his art as if he were trying to begin a new life?

TAPIES: Perhaps what I meant was that in the work of Miró I see a renewal of art itself. I believe that Miró did more than Picasso for the language and the freedom of painting.

In respect of the language of materials?

TAPIES: In terms of materials, expression, form and colour. Another thing is that Miró was a whole generation younger than Picasso. He was influenced by the movements which sought to revive primitive art and took an interest in the expressive language of children, of the unconscious. It seems to me that all these ideas are more clearly visible in the work of Miró, whereas Picasso's thinking was still tied to the themes of

early modernism. Of course, he also unleashed a revolution and he, too, was influenced, long before Miró, by African and 'primitive' art. But the artists of Miró's generation were more mature and better able to assimilate the messages from other civilizations which have shaped modern culture.

And Klee?

TAPIES: With him it's perhaps just more conspicuous. In Klee's work there's a complete synthesis of all these seminal ideas which went into modern art.

Picasso, I rather think, was trying to demolish classical art: he was destroying classical painting rather than putting forward proposals for a new kind of painting. But Miró and Klee contributed something quite new. To us they appear more modern, and of course they are closer to us in time.

Doesn't your preference for Miró also have a good deal to do with the fact that he, like you, was a Catalan, whereas Picasso, in terms of both temperament and subject matter, was an Andalusian? You have a number of interests in common with Miró. He loved all the things that you like as well: nature, the countryside, folk art, simple materials, Romanesque art, Art Nouveau, graffiti ...

TAPIES: That's the cultural baggage we've inherited. The same thing applies to a large number of artists, of course, not just to Miró. It's a cultural, philosophical and spiritual context, and no doubt it also stems from the collective unconscious, because I've never set out to do Catalan paintings or anything of that nature. It can happen, but it's not deliberate. The same is surely true of other artists in other countries. It's not my intention to paint in a national style.

SURREALISM

In the immediate post-war period artists in Germany sought to revive the abstract art of the 1920s and early 1930s. In Spain, on the other hand, the Surrealists were still seen as the leaders of the avant-garde. Surrealism played an important part in your early work, too. I know that the Spanish Surrealist tradition is different from that of other countries, but does that fact alone suffice to explain the phenomenon? In Paris the influence of Surrealism was already on the wane.

TAPIES: But after the war I think there was a minor renaissance of Surrealism. The leaders of the movement – Max Ernst, for example – came back from the United States. Breton was still publishing Surrealist magazines, such as *Le Surréalisme même*, which he edited himself, and

several other publications, including *Medium* and *Bizarre*, which were founded at his instigation. There was even a whole new generation of Surrealist painters, whom Breton included in the second edition of *Le Surréalisme et la Peinture*. In Paris Surrealism was still very much alive.

Alive, yes, but it was no longer the avant-garde.

TAPIES: In Spain people were still influenced to some extent by Miró and Dalí. It's certainly true that we took more notice of Surrealism than artists in other countries, and that we felt a greater affinity with the Surrealist artists who were living in France. Although I was impressed by the abstract art I saw in Paris, I had considerable reservations about it, because my artistic approach had been shaped by Surrealism.

Was Spanish Surrealism perhaps also a kind of weapon against the tradi-
.tionalism and backwardness of the country, which at that time was still in
the grip of reaction? In Spain dreams have always played an important
part in both literature and painting, from Calderón and Cervantes to
Goya.

TAPIES: Right from the outset, Surrealism contained a number of interesting elements which were directed against Spanish clericalism and reactionary politics. Dreams were perhaps a kind of tactic, a means of opposing the conservative tendencies which had persisted for centuries. That's the side of Surrealism which is concerned with social and political opposition, but the movement also had other, cultural aims which have an importance for us today. When I started to paint I learned a lot from reading, from writers such as Foix, who clarified a number of things for me. Foix knew a lot about the tactics of Dada, which I found extremely useful in opposing the Franco regime. I adopted various techniques of combat from Dada.

Did Dada have any effect in Barcelona at the time when it first emerged?
Did it exist at all?

TAPIES: Not as an organized movement. There were a few writers who were influenced by Dada, and by Futurism as well – people like Foix, Salvat Papasseit and Junoy, who was in regular contact with Apollinaire, although he was a good deal younger. In 1934 Foix published an extremely informative account of the Dada movement, written in Catalan, in the magazine *D'aci d'alla* [From Here to There]. This article, and the illustrations which accompanied it, gave me a lot of new ideas and greatly influenced my work.

In the visual arts there was Picabia, of course, who lived in Barcelona for a while during the heyday of the Dada movement [see fig. 26, 27]. It was here that he published the first issues of the magazine *391*. And I'm sure that his work left certain traces of Dadaist influence.

You mentioned that, in the 1940s, Foix and Brossa were the theoreticians to whom young artists looked for guidance. Does this mean that writers played a central part in shaping the ideas of the avant-garde?

TAPIES: It's not as simple as that. Brossa and I both started out at the same time: we were good friends, and we spent a lot of time discussing things. I think one can say that the influence was mutual.

What about Foix?

TAPIES: Foix was already a kind of legend. He was much older than us, and he introduced us to the ideas of Dada and Surrealism after the war. In the 1930s he had written extensively on these subjects in such magazines as *Monitor*, *L'Amic de les Arts* and *La Publicitat*, but of course it was only after the war that his work came to my attention. The texts which first brought us into contact with modern art were passed on to us by Foix and Joan Prats, a close friend of Miró who also became one of my friends and patrons and gave me a lot of documentary information about the art of the pre-war period.

Did you also try to contact Breton and his circle during your first visit to Paris in 1950?

TAPIES: No. I carried on studying Surrealism by reading magazines, rather than by seeking any kind of direct contact with Surrealist artists. Of course, the main reason for this was that when I first went to Paris I couldn't speak a word of French, so it was difficult for me to gain an entrée to the Surrealist world. Apart from this, there was also the fact that I was obsessed with the idea of meeting Picasso and other artists, but not writers.

But Breton was, after all, the head of the Surrealist movement, and at that time you were still working in an entirely Surrealist style: indeed, you carried on doing so until 1954.

TAPIES: By the time of my first exhibition in Paris Surrealism was already in decline: it had become decadent, and people were rebelling against it. Even Michel Tapié, who still retained a certain connection with the movement, was beginning to adopt a quite different stance. My first one-man show in Paris was in 1954/55, following a group exhibition featuring one of my pictures in 1954. The group called itself *Phases de l'Art Contemporain*, and it was largely made up of second-generation Surrealists. This was its first exhibition, organized by a writer who still had close ties with Breton, and it was this man who invited me to participate in the show, which was held in a kind of garage rented for the occasion by the Galerie Creuze, a gallery which no longer exists: it was not far from the Galerie Maeght [now Galerie Lelong]. I also took part in a small group exhibition at the Galerie du Dragon.

Was that a group of Spanish artists?

TAPIES: No, it was international. Apart from me, there was only one Spaniard: Nieva. He introduced me to the gallery. The director was a young writer, a member of the younger generation of Surrealists.

When did you meet Fautrier? Did you actually know him personally?

TAPIES: I did meet him, but I hardly spoke to him. He also belonged to the group headed by Michel Tapié.

And Dubuffet?

TAPIES: I never met him. I was familiar with his painting, of course, but I never knew him personally.

I met him once, when he was already in his eighties. He invited me to his house, which was small and spartanly furnished, in Montparnasse. He lived like a monk in a cell. The experience left a deep impression on me.

TAPIES: I was greatly impressed by the painting of Dubuffet and Fautrier. But what influenced me most at that time was Brassaï's photographs of graffiti [see fig. 29].

Did you know Brassaï personally?

TAPIES: I never met him either, which is something I really regret, because he was an artist, a photographer, whose work I liked a great deal.

FILM AND LITERATURE

Referring again to mime and role-playing in the work of Pomès, are you interested in mime, in the grotesque expressions and gestures to be found, for example, in silent films?

TAPIES: Yes, I'm fascinated by silent film. I've even put together a little library of silent films, starting with the work of Georges Méliès and Dreyer. Silent film was more experimental: it was an avant-garde form of cinema. It led to the invention of a new language, and that's why I find the old films far more interesting. Later on, film became very commercialized. People started transposing the theatre, with its endless dialogues, on to the screen, and I think that's awful. I'm mainly interested in silent film, in the work of the Swedish directors Stiller and Sjöström, for example, together with some of the Russians and the German Expressionists. I feel particularly drawn to the films of the Nordic countries: they have a strangely mystical side and show a deep sense of affinity with nature.

Does this interest also extend to the films of Bergman?

TAPIES: I prefer Dreyer, his mentor. But I think Bergman is certainly one of the best living directors. Another director I find interesting is André Delvaux, a Belgian who has made only two or three films, but the quality of his work – *L'Homme au Crâne Racé*, for example – is excellent. It seems to me that there are a number of good directors around at the moment. I believe that there's a new school of film-makers emerging in Germany – people like Syberberg and Wenders – but I don't know their work well enough.

Looking at some of your furniture assemblages, I get the feeling that you ought really to be interested in film as an extension of your art. Have you ever tried to express your ideas in another medium?

TAPIES: I am indeed interested in the possibilities of film. One can express things in film that can't be said in painting, theatre or even photography. Film has a language of its own which I find very exciting. On the screen one can reproduce the drama of nature, or street scenes, or the intimacy of a love affair, all in microscopic detail. These are things which were impossible before the advent of the cinema. I'm fascinated by all these possibilities: the subjective camera, the flashback, montage, the intelligent use of the soundtrack. However, I've never thought of taking up film as a new area of artistic activity.

Not even to the extent of making a short film with other people?

TAPIES: No. In my opinion, every activity calls for total commitment. One has to devote all one's energies to one's work. And this is precisely not the case in what I've seen of the various film-making activities of visual artists, in underground film and video art, which is often a very half-hearted affair. Although I think it's a good thing that people are rediscovering the experimental possibilities of avant-garde cinema, the results of these experiments are generally pretty amateurish. They look as though they were made as a Sunday pastime, and I think that's embarrassing for an artist. If you don't really work at things properly you end up repeating yourself or relapsing into cliché and puerile nonsense.

Another striking characteristic of your art is its proximity to poetry.

TAPIES: Yes, that's an important subject. These days it's fashionable to say that art has to be dematerialized in order to save it from commercialization.[17] On the other hand, one notices that poetry is tending more and more towards the status of an object, although there's nothing really new about that either. My works are often paintings, objects and poetry in one: in a way, they are visual poetry. Some of them are sited on the boundary between art and literature. They use a language which one might call 'meta-poetry' or 'meta-painting'. My pictures often include texts, words and bits of writing, sometimes with imaginary alphabets,

signs, allusions and exclamations. I have created a symbiosis of two different means of artistic expression by collaborating with writers, especially with my friend Joan Brossa, the Catalan poet. We have published books and designed posters together: for example, we produced a book entitled *Novel.la*[18] in which the visual and the poetic are integrally connected. I really do believe that pictures are inseparable from poetry. As you said once before, my 'dirty' painting is organized in a deliberately ambiguous way, like a flexible linguistic structure. Reality is never directly present in the picture: it has to be created, by a process of association, in the mind of the viewer. What we call 'reality' in the picture is in fact merely a sign, a cryptic symbol of the real. However, there has always been a mysterious link between the signifier and the object for which it stands, although they often appear quite separate. This is the phenomenon of *maya*.[19] If, like the Buddhist philosopher Nagaryuna, one were to imagine the word and the object as integrated, then the very word 'fire' would cause things to burst into flames. But it's equally impossible to regard words and things as separate, since a name cannot exist without an object, and vice versa. Pictures and words are very mysterious, and also very dangerous.

At the root of all these things lies the idea of combining purely abstract painting with literary and visual images. But my painting isn't abstract, although it's often classified as such. I won't put up with any form of limitation. I'm just as adamant about that as the Surrealists, who saw the refusal of the abstract artists to allow the slightest element of reality into their pictures as a form of self-imposed punishment. But, needless to say, this doesn't mean that one has to go back to figurative painting. I think that good painting, like the word, is always ambiguous.

But let me come back to the subject of poetry, which has always been very closely bound up with form. You only have to think of Oriental poetry. Calligraphy, too, is a materialization, an idea which has been given form. This applies to typefaces, as well as handwriting. Each generation, in so far as it looks for new ideas and tries to express them, also looks for suitable forms. Consequently, every period has evolved its own typefaces; even the paper and the forms of book-bindings have continually changed. This means that there is no clear dividing line between the poetry of the word and the poetry of the visual arts, since poetry always requires materialization. This is already apparent in the poetry of Mallarmé.

In the coup de dés.

TAPIES: Yes. It was in the *coup de dés* that Mallarmé gave poetry very definite material forms. He realized the necessity of translating thoughts and art into material terms. As he wrote in *Quant au livre*, 'Ton acte toujours s'applique à du papier; car méditer, sans traces, devient évanescent.'[20]

Was the title which Joan Brossa devised for the magazine Dau al Set *inspired by Mallarmé?*

TAPIES: I don't think he had Mallarmé in mind: any allusion was purely unconscious. It's also possible to see an analogy with Georges Hugnet's book *La septième face du dé* [The Seventh Face of the Die]. But I don't believe that Brossa was directly referring to either of these works. Like me, he loves all kinds of magic: conjuring tricks, games of chance and so forth. The dice are a very magical thing.

Is the motif of the top-hat combined with numbers, which frequently appears in your pictures, related to games of this kind?

TAPIES: You're thinking of conjurers pulling things out of hats? You may be right, because there was an illusionist, a quick-change artist called Frègoli, whom I studied very closely. He used to perform plays with seven or eight characters, playing all the parts himself: he could switch roles so quickly that he didn't need other actors.

Various writers have maintained that the literary characters they created were not imaginary figures but parts of themselves, expressing the various facets of their own personality. Gerhart Hauptmann, for example, once said: 'The origin of drama is the split personality, divided two, three, four, five or more ways'.

TAPIES: One finds the same idea in Hindu philosophy. Matter, the *atman*,[21] always stays the same, and diversity consists in form, in what is known as *maya*. Here, too, unity entails diversity. It was my friend Brossa who drew my attention to Frègoli. He has a whole collection of photographs and posters from his shows. When I started to look more closely at Frègoli's art, an art of transformation, I realized that it, too, has a symbolic meaning. So we joined forces to produce a book in his honour.[22]

And what are your preferences in literature?

TAPIES: There, things become a good deal more difficult, because my preference is for poetry, which is very much tied to the language in which it's written. I have to limit myself, in the main, to names from my own country. Starting with our classical authors, our troubadours,[23] Ausiàs March and Jordi de Sant Jordi deserve a mention. Then there are the writers who emerged at the turn of the century, in the period we call the *Renaixença*. Catalan literature began to show signs of extreme decadence in the seventeenth century and, from the early eighteenth century onwards, it was completely stifled by Castilian centralism. But towards the end of the nineteenth century there was a renaissance of Catalan culture, with the revival of the *jocs florals*, the bardic competitions that date back to the Middle Ages, when Catalonia was still an independent

country.[24] One particularly fine poet emerged from the *Renaixença*, a man called Jacint Verdaguer i Santaló.[25] He was a priest, and in his poetry there are conventional religious elements that I don't like, but I like his language all the more: his descriptions of the Catalan countryside are highly inventive. Verdaguer initiated a whole new tradition in Catalan poetry. Three of the writers who particularly spring to mind are Joan Maragall i Gorina,[26] Josep Carner and Carles Brancons Riba,[27] and then there are the contemporary writers – Foix,[28] Joan Brossa[29] and Salvat Papasseit[30] – who were closely allied with the French Surrealists. Salvat Papasseit, who died some time ago, was initially influenced by the Futurists, but he subsequently evolved a style of his own, a very human and sensitive style which is simply wonderful. As for Brossa, there are many links between his work and mine. There are also a number of younger writers whom I find interesting: the poet and essayist Pere Gimferrer, for example.

As far as the literature of other countries is concerned, I'm particularly fond of Chinese and Japanese poetry, especially the *haiku*,[31] and I like Walt Whitman and Edgar Allan Poe. But let me come back for a moment to my friend Joan Brossa, whom I greatly admire. His work shows affinities with both Surrealist and Oriental poetry. He writes short poems full of paradoxes: some of them are very similar to Japanese *koan*.[32]

And what about Spanish or Latin-American literature: Jorge Luis Borges, for example? The metaphoric language of his Historia universal de la infamia *is surely something you find interesting.*

TAPIES: Don't forget that my mother tongue is Catalan, not Spanish. And as far as Borges is concerned, I haven't read much of his work, but I find his political attitudes repugnant. I'm convinced that these human failings also leave their mark on his writing.

What led you to collaborate on a book with Octavio Paz? I've read several of his essays on art, and there seems to me to be absolutely no common ground between his views and yours. His ideas about art strike me as highly conservative.

TAPIES: It probably came about as a result of the attraction we both feel to the Far East. He knows the East well: he lived in India for a while. It was Gimferrer who introduced me to Paz. He talked to me about his ideas on poetry and contemporary art, explaining how he sees everything from an Oriental perspective. And so I thought there might be a certain affinity between us. I also find his defence of aesthetics as a form of morality interesting. I like that, too.

You have always been closely associated with writers. Have you ever written any poetry yourself?

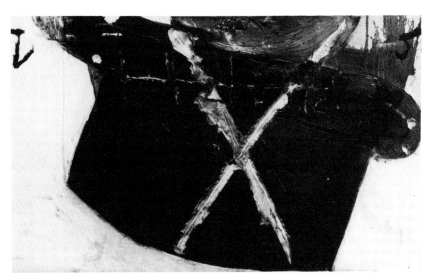

Fig. 74 *Upside-down Hat*, 1967

TAPIES: No. I've never written rhyming poetry, none whatsoever. But I have been told that some of my pictorial compositions are similar to poetry. Some of them include whole sentences. It's a form of poetry without rhyme or metre, an 'irregular' poetry, as Joan Brossa says. It doesn't abide by any rules.

When I asked that question I was thinking of Dau al Set *and your Surrealist period, which might lead one to suspect that you had tried your hand at poetry.*

TAPIES: No, I consider myself lacking in any form of literary talent. I haven't got the ability to do anything literary.

But you use language in a vivid, often poetic way.

TAPIES: Perhaps I'm like Molière's Monsieur Jourdain. I compose poetry without being aware of what I'm doing.

When did you start writing? Did you publish anything in Dau al Set?

TAPIES: No, I never wrote anything for *Dau al Set*. I started writing very late in the day, and the reason why I took up the pen was that I wanted to state my point of view in a Catalan magazine at a time when the entire cultural life of Barcelona was dominated by a single prominent critic, Alexandre Cirici, who died some years ago. I felt that it was necessary to show young artists and younger people in general who were interested in art that Cirici's pontifications were not the only legitimate opinions.

So Cirici wielded a kind of papal authority?

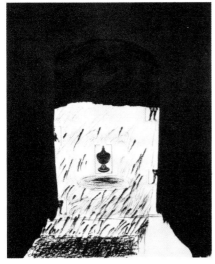

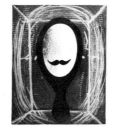

Fig. 75 *Letters* (or *Playing Cards*)
 for Teresa, 1974

Fig. 76 *Frègoli*, 1969

TAPIES: Yes, but it wasn't even his intention to do so. He became a sort of Pope because there was nobody else writing in Catalan who was capable of engaging him in a discussion or a dialogue about art.

Have you also published texts about the work of other artists?

TAPIES: Yes, a few short pieces, on Miró, Picasso and Jean Arp, for example. And I've also written several things for young artists.[35]

Were these texts in which you were also trying to clarify and explain your own artistic approach?

TAPIES: They were mainly things that other people asked me to write, but I only accept commissions of this kind if the subject is one I'm keen to tackle. For Picasso, for instance, I wrote a short foreword to a monograph which was published in French. I've also written texts about Saura and for a group of young artists: Broto, Grau and Tena. I don't know if you're familiar with their work. Broto is becoming quite successful, not just in Spain, but on the international circuit as well. There are regular exhibitions of his work in Paris.

Dalí once published an article about your work in the American magazine Art News. *What's the reason for this always having been omitted from your bibliography?*

TAPIES: I'm sure it was simply forgotten ... or perhaps I didn't ascribe much importance to it. It wasn't a long article, just a few lines, a small amount of text with a lot of reproductions. Nevertheless, I'm quite proud of that little bibliographical item.

Are there any other artists who have written about your work? Miró springs to mind ...

TAPIES: Yes, Miró. He made a few brief comments. As you know, he wrote very little, but he commented on my work several times. That's odd ... I've never included those texts in the bibliography either. Your question reveals an oversight. I suddenly recall that Saura also wrote an article about my work, a long text dealing with a single picture.

Which one?

TAPIES: It was a work called *The Matter of Time* [fig. 77]. In the USA Paul Jenkins has written quite a lot about me.

Has Motherwell ever commented on your art?

TAPIES: No, the opportunity has never arisen. But it would be a natural thing for him to do: he likes my work.

PHOTOGRAPHY AND PAINTING

We've never really discussed photography. Is photography also a source of inspiration for your work? You once talked about the circle of artists headed by the photographer Pomès in Barcelona, and you have often mentioned the names Gomis and Brassaï.

TAPIES: In those days, when I was still trying to find my own style of painting, to find an artistic identity, I was also interested in photography. Because the invention of photography and film has completely changed our attitude to the visual arts, I often found myself asking the question: what is painting? I was interested in photography in an indirect way, with the aim of preventing my painting from becoming photographic.

But there's also abstract photography, which emerged at a very early date. One thinks of the Bauhaus, of artists like Moholy-Nagy, of the Russian avant-garde and of the films of Eisenstein, which incorporate entirely abstract rhythmical elements.

TAPIES: I even have a number of films by Eisenstein in my private *cinémathèque*. But you must remember that the situation in Spain was quite different from that in other countries. In Spain we had to fight against photo-realist painting.

Which still exists today.

TAPIES: Under the specious label 'Spanish Realism'. But I see photo-realism, whether in drawing or painting, as a big mistake. These are all

Fig. 77 *The Matter of Time*,
 1983

things that can be done mechanically: there's no point in wasting one's time on them.

However, photography does have a part to play in reproducing and documenting the external appearance of reality, which is quite separate from the business of painting.

Have you ever found useful ideas in photographs – press photographs, for example?

TAPIES: Yes, possibly so. The photographs of Brassaï have certainly been a source of ideas [see fig. 29, 30].

What about photographs of the Spanish Civil War?

TAPIES: Yes. On one occasion I even wrote an essay on the subject. At the time of the Civil War, Barcelona was like New York today, with graffiti everywhere. But the graffiti in New York are more aesthetically attractive, less real and harsh than in Barcelona.

In Munich I recently saw an exhibition of photographs from the Spanish Civil War: there were no graffiti in evidence, though. The photographs had been taken by two Germans: Hans Namuth and Georg Reisner. Leafing through the catalogue, I discovered that you had designed the frontispiece. Did you do this lithograph specially for the exhibition?[34]

TAPIES: Yes, Namuth asked me to do it.

Have you known him for a long time?

TAPIES: He came to visit me in Barcelona one day and took a large number of photographs of me. We became friends. I find him very sympathetic because he sided with the Left, with the Republicans, during the Civil War.

I often wonder whether you really remember the Civil War or whether your mental picture of it has been shaped by stories told by your parents or by books and photographs. You were still very young at the time.

TAPIES: At the end of the war I was fifteen. By and large, it's probably true that I registered the events of the time on a subconscious level, rather than being directly aware of what was going on. But there are a number of things I remember very clearly, such as the sight of the first band of volunteers going off to join the Republican army. The militia requisitioned all the cars, which were decorated with graffiti, like the trains on the New York subway. That left a deep impression on me.

Are there any books about these Civil War graffiti? Did anyone ever produce any kind of photographic documentation?

TAPIES: I don't think so. Nobody saw the graffiti as having any aesthetic value.

Not at the time, no, but later on, perhaps?

TAPIES: Photographs have been quite important to me, in the first instance because I'm a book-lover: I enjoy looking at books. I have always kept an eye open for books on photography, and for magazines, too . . . well, more for magazines, really. In *Minotaure*, for example, there were a lot of reproductions of photographs by Brassaï [see fig. 29], and I think it was those pictures which first caused me to realize the significance of graffiti.

You have done some collages which incorporate photographs.

TAPIES: Not many, only a few . . . For example there's a collage I made by sticking a photograph of a man wearing a tie on to a lithograph. It was included as an extra in the bibliophile edition of *Sinnieren über Schmutz*, the book I did with Mitscherlich.[35] In one of my early pictures I also used a photograph of a baby's head.

Yes, I know it: a baby's head in the form of a medallion attached to a ribbon.

TAPIES: Hanging in a void. Perhaps there are one or two other collages like that; I can't remember.

In the book on Frègoli there was a photograph covered with a sheet of white paper, torn in the shape of a T.

ART AND POLITICS

Are your memoirs based on diaries?

TAPIES: No, I've never kept a diary.

So how did you manage to remember all the details so clearly?

TAPIES: The memories came flooding back when I started writing. I wrote about the things I could still remember: perhaps there are other things that are also very important, but which I've simply forgotten. When I finished the book the memories evaporated; it was as if they had been erased from my mind. Nowadays, if I want to remember something I have to read the book again.

Why did you publish your memoirs at such an early age?

TAPIES: I had just come out of prison, following the episode when we barricaded ourselves in the Capuchin monastery [36] and the police hauled us out and arrested us. There was something of a scandal; my name was all over the newspapers. Everybody knew that I'd been in jail. It was only for three days, but it was a very embarrassing experience, and it meant that I had a criminal record. I thought people in Barcelona would get the impression that I was a bad character, so I wrote my memoirs to show that I was a decent fellow after all. There was a whole group of us – students, professors, intellectuals and artists – and our meeting at the monastery was the first protest of its kind ever. It was before the Burgos trial.

A protest under the protection of the Church...

TAPIES: At that time any assembly of more than seven people – or some such number: I can't remember the precise details – was banned. As in other dictatorships, there was a law against forming any kind of group. So our secret meeting was illegal. But by holding it in a monastery, we enjoyed special protection. The police weren't allowed to enter the monastery, but they threw a cordon round it and camped outside for three days. It was like being in a fortress. Then there was a meeting, chaired by Franco, of the council of ministers, and the Minister of the Interior ordered the police to go in and get us. They broke down the door and arrested us all.

And what did they do with you?

Fig. 78 *Three Brooms*, 1970

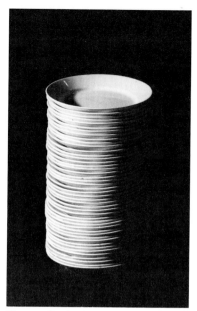

Fig. 79 *Stack of Plates*, 1970

TAPIES: They confiscated the students' passports and let them go, but the professors, intellectuals and artists were carted off to prison. We were locked up in tiny underground cells underneath the police headquarters – it was all very medieval. They kept us there for three days and interrogated us several times.

Were you also with the group which barricaded itself in the monastery of Montserrat?

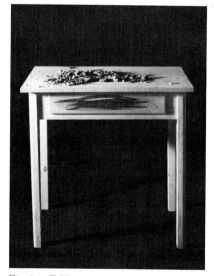

Fig. 80 *Table*, 1970

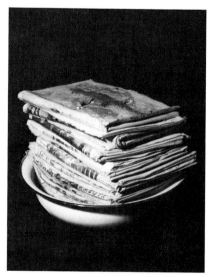

Fig. 81 *Pile of Newspapers*, 1970

TAPIES: Yes, I was at Montserrat, too.

I believe Miró was there as well.

TAPIES: Yes. Teresa and I talked him into it. We were all in Tarragona: Miró had donated a tapestry to the hospital there, and a whole group of us had gone with him. Over lunch we persuaded him to come on with us to Montserrat. Together with Dupin, Delong and several other foreigners, including Vargas Llosa, we drove off to the monastery in the afternoon. When we got to the meeting we were told that things could become very awkward for the foreigners. And since we were also worried about Miró because of his age, we decided to leave the meeting at the end of the evening. So we were already gone by the time the police arrived.

At exactly the same time I was in Barcelona for the opening of the Picasso Museum, a major event which turned into a clandestine meeting, because Picasso had barred all representatives of officialdom from attending the ceremony. So there was only a small gathering of foreign art critics and intellectuals from Barcelona, who were extremely keen to make contact with us. Some of them had already had their passports confiscated.

TAPIES: At the time of the Burgos trial we seized on any event which gave us an opportunity to talk to journalists. When we barricaded ourselves in the Capuchin monastery we were fortunate in that, only a few days previously, a new set of regulations concerning the press had come into effect. Up to that point there had been a system of preventive censorship: the newspapers all had to be passed by the censor before publication. The new law transferred the responsibility for censorship to the pub-

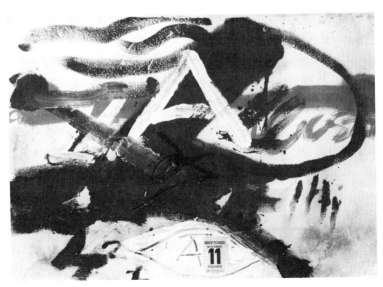

Fig. 82 *11 September, 1977*

Fig. 83 Front page of a supplement for the newspaper *AVUI*, Barcelona, 11 September 1979

Fig. 84 Design for a mosaic in Plaça Catalunya at Sant Boi de Llobregat, 1983 ▷

Fig. 85 Part of the mosaic in Plaça Catalunya, Sant Boi de Llobregat ▷ ▷

lishers and editors. That created new possibilities which the newspapers exploited to the hilt. They were able to report on what was happening at the monastery.

Did you draw on the events at Montserrat in any of your works?

TAPIES: Yes, there are several which refer to the life of the Capuchin monks, a monastic order towards which I felt a certain sympathy.

What kind of works?

TAPIES: I did a number of objects, paintings and drawings in a 'poor art' mode, using motifs which are totally humble.

Objects from the everyday life of the monks?

TAPIES: Yes: a simple broom, for example [fig. 78]. The object-sculpture with the stack of plates [fig. 79] was also inspired by the events at the monastery.

What about the experience of imprisonment?

TAPIES: These objects also refer to the time I spent in prison [see fig. 80, 81]. There was another political meeting, a convention of all the opposition parties, which I didn't attend, but the organizers asked me to do a lithograph to help with their fund-raising efforts. The picture was also used for a poster.

A year after Franco's death you painted a picture which was coloured blood-red; stuck on to it was a leaf from a calendar, showing the date 11 September [fig. 82].

TAPIES: The eleventh of September is a Catalan public holiday com-memorating the events of 1714, when the King of Spain deprived Catalonia of its autonomy.

A day of remembrance which, I believe, was outlawed by Franco, and a year after his death you included the leaf from the calendar in your picture as a reminder of what the eleventh of September means to the people of Catalonia.

TAPIES: I painted the picture, and I also made a mosaic [see fig. 84, 85]. The first celebrations were held in a small village called Sant Boi de Llobregat. There was a demonstration in the village square, and it was there that I installed the mosaic, which is entitled *11 September.*

Something else that springs to mind is the title page with the inscription '11 September' which you designed for a newspaper supplement [fig. 83]. Are there any other pictures which directly refer to the political events of that period?

TAPIES: Yes, there are quite a number. For example, I painted a homage to a young man called Puig Antich, who was condemned to death by the Franco regime. It's a very large picture.

Yes, I remember now. You told me about it years ago: that was the picture which included items of the victim's clothing.

TAPIES: It's the picture with the torn pullover. There are several other works with similar allusions. At that time I was caught up in the prob-lems of the opposition. People often told me what was going on and

asked me to help. For example, someone rang me up the night before this poor boy was due to be executed and asked me to contact Malraux and get him to intervene with the government to save the boy's life. A number of other people had already tried to use their influence on his behalf, but Franco wasn't prepared to listen. When I tried to get hold of Malraux on the phone, his sister answered and told me that he had gone to bed and taken a sleeping tablet. But the next morning he wrote me a letter saying that an intervention by him would in any case have had no effect, because he himself had been condemned to death by Franco.

Yes, when he was fighting on the Republican side in the Civil War.

SERIES – VARIATIONS – PRINTS

During the first phase in the development of your work, up to 1954, you often produced pictures in series, with a literary or political content. There were the series Hommage à Lorca *and* Hommage à Miguel Hernandez, *and there were other cycles of pictures referring to the poetry of Rafael Alberti and Joan Brossa. The most extensive series of this kind was* Natural History, *a set of about twenty drawings which you did in 1950/51 [see fig. 86, 87]. Here, as in the portrait of Hitler which you did in 1950 [fig. 88], you addressed the issue of Fascism in a satirical manner. Were these works partly inspired by the drawings of Otto Dix and George Grosz or the photo-collages of John Heartfield?*

TAPIES: I'm not really sure. Those pictures were the product of a general Marxist mood which affected me at the time, when I was going through a bout of what might be called political measles. I very soon developed an aversion to the element of caricature in the work of those artists. Many people of my generation came under the influence of Communism as a consequence of their opposition to the Franco regime. By waging war on Communism, the Fascists aroused our interest in the very thing they were attacking. But I quickly realized that, with the exception of Picasso, most of the Communist artists were producing bad art. I thought about this a lot, and then I completely turned my back on this kind of art, no matter whether its message was political or Surrealist. I gave up painting pictures with a literary or political theme. When I came back from Paris I went into retreat and locked myself in my studio in order to find an artistic vocabulary of my own, a sculptural language.

But later on there were several further series of pictures which made a political statement – the Suite Catalana, *for example.*

TAPIES: The *Suite Catalana*, with the image of the Catalan flag, was a series of etchings. I also continued to do cycles of drawings, but the

Fig. 86 *Fascism.* 'Natural History Series', 1950/51

Fig. 87 *Revolt.* 'Natural History Series', 1950/51

impasto paintings are all individual works. The only things I've done in series have been drawings or prints.

In your graphic works the destructive element in your painting – the vehemence with which you attack the picture, the holes and fissures in the paint surface – becomes a trompe l'œil *illusion. Doesn't this conflict with your notion of artistic authenticity?*

TAPIES: But when I'm making prints I'm dealing with a copper plate which is dipped in acid, and that's a form of gestural expression. I use a copper plate like a piece of paper: the operations which I perform with my fingers and my brushes are the same as if I were handling paper rather than metal.

But there are no holes or cracks in the plate: on the print the holes are only seen as marks.

TAPIES: That's just another way of attacking the picture, of attacking the blank white surface. In this case the acid replaces the knife, but in my mind it's the same as if I were actually making holes in the picture. When I dip a copper plate in a bath of nitric acid, the acid becomes the knife. I don't think of it as an imitation of a hole: for me, the hole is real.

The transformation of a hole, a mark...

TAPIES: But sometimes I even bore holes in the plate or burn holes in the paper. I'm convinced that in etching, at least, I remain true to myself. If it's the lithographs you're talking about, then I'd agree with you. There it's a kind of... well, I wouldn't call it imitation, but the various stages of

the process are separate, the shaping of the relief is a distinct operation. But in etching one thing dovetails into another. The crack which you later see on the paper is directly visible on the plate.

Certainly it was different when I first started to do etching. I still had a somewhat exaggerated respect for the plate. I used to do a preliminary drawing and then transfer it to the plate, working very carefully and methodically. That's how my first prints were made. These days, however, I treat the copper plate just like a piece of cardboard or paper. The technique of lithography is different. It's a two-dimensional technique with no relief effect. But even when doing lithographs, I've tried to introduce an effect of this kind. I was one of the first Western artists to use relief printing. Braque used it as well, but only on a few occasions. In etching you can make the relief with a single plate.

I recently saw your latest book at the Galeria Taché: the series of etchings based on texts by Llull. You spent over ten years working on it.

TAPIES: Yes, there were a lot of problems with it. The first publisher I offered it to wasn't prepared to take the risk of publishing it, and after that it took a long time for me to find another one. Eventually, it was accepted for publication by two galleries, Taché and Lelong.

Which texts by Llull did you choose?

TAPIES: I was advised by Pere Gimferrer, who knows Llull's work very well. The introduction was written by an expert on medieval Catalan literature, a very learned clergyman called Batllori.

It's really quite astonishing: there are passages in Llull's writings which read exactly like descriptions of my pictures. They are closely related to my way of thinking. And it was Gimferrer who found them. Llull wrote so much that one has to know his work very well indeed in order to track down the relevant passages. I'm not in a position to do that: I'm not sufficiently familiar with his writings, although I own a number of very fine old editions of his works [see fig. 4,5]. I showed you them once, remember? Some of them are hand-illustrated. It was these old books which inspired me to do the etchings. However, when I compare my pictures with these fifteenth-century illustrations, I find my own work completely worthless.

Have you studied the writings of any other medieval mystics – Hildegard von Bingen, say? She was a remarkable scholar in several different fields, not only in the sciences, but in the arts as well – music, for example.

TAPIES: I know some of her music. I very much like the music she wrote for female-voice choirs: it's like Gregorian plainsong. I even have a record of it.

Her musical mystery play Ordo Virtorum *was recently staged in the Rhineland.*

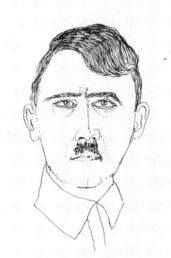

Fig. 88
*Portrait of the Führer
of the Third Reich,*
1950

*Retrat del Führer del tercer Reich
que va ser declarat "criminal de gue-
rra" per les nacions que derrotaren
l'Alemanya.*

TAPIES: An orchestral work? I didn't know she'd written anything like that.

You did a similar thing to the Llull book in one of the issues of Dau al Set, *where you juxtaposed your own work with a text by a medieval monk called Enrique de Villena [fig. 15]. Are there any further examples of this kind of juxtaposition?*

TAPIES: Llull wasn't just a monk; he was a philosopher, too. But to answer your question, the first time I juxtaposed a set of etchings with a medieval text was in the book. Llull was a mystic who founded a monastery. He also tried to organize a crusade against the Arabs – but I'm sure you don't approve of that. He travelled to North Africa and ended up in prison there. But the thing that really interests me about him is that he was a scholar, a scientist. I find this combination of science, mysticism and art fascinating. He was both a poet and a man of action, and he brought all his knowledge and his ecstatic visions to bear on his activities.

Beuys was also very interested in mysticism. Did you know him personally? Did the two of you ever correspond?

TAPIES: No, we never met. Somebody once suggested arranging a meeting between us, but it never came off. He had a rather theatrical manner: I think he preferred talking to large audiences, which isn't my style at all. That was probably an obstacle to any kind of meeting. I once met an artist in Vienna who is also interested in ritual practices.

121

That must have been Hermann Nitsch.

TAPIES: Yes, that's right, it was Nitsch. I also met Rainer in Vienna. He came to my exhibition and we had dinner together afterwards.

Did you know that he also started out as a Surrealist? Like you, he went to Paris for the first time in 1950 and visited Breton. Shortly after that he changed direction entirely and began to smother the strange, surreal images of his early work with thick layers of dark colour. On one occasion, at the time when he was doing his first overpaintings, he also juxtaposed his work with the writings of a mystic.

TAPIES: I've never seen any of those pictures. The only things of his that I know are the paintings on reproductions of images of Christ's head. But I'd like to have one of his pictures in my collection. It's interesting that he also paints with his fingers, like me when I'm alluding to things such as the Catalan flag.

OBJECTS AND SCULPTURES

One very rarely sees any of the objects which you made in 1970 and 1971 [see fig. 78–81, 89, 91]. As far as I know, not a single one has been acquired by a museum.

TAPIES: Yes, that's right. Apart from Andreas Franzke, who mentioned me in his little book on the sculpture of artists who are principally painters,[37] the art historians have always overlooked my work as a sculptor. But even in painting, my art is an art of objects. There are allusions to furniture – to chairs, for example [see fig. 41, 43] – and I often glue objects into my pictures. The collages follow directly on from my sculptures.

When you made these objects in the late 1960s and early 1970s were you at all influenced by Pop Art, by such artists as Rauschenberg and Jim Dine?

TAPIES: I don't know. That was the time of the Neo-Dada movement, for which objects were a central concern. But the idea of the object was already present in my pictures. Unlike most other painters, I have always regarded pictures as objects, rather than as windows. That's why I give the surface the appearance of a relief; sometimes I've even worked on canvas or board from behind [see fig. 92]. My aim is to transform the painting into a magical object, a kind of talisman with the power to heal by touch.

Although I've always had a general interest in objects of all kinds, the ones which have made the biggest impression on me are those of the

Fig. 89 *Desk with Straw*, 1970

Dadaists and Surrealists: the collages of Schwitters, for example, which undoubtedly have been a major influence on my work.

Do you have anything by Schwitters in your collection?

TAPIES: Yes, a small collage from the 1930s which I like a great deal.

Fig. 90 *Brown with Stockings*, 1970

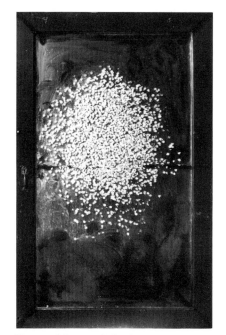

Fig. 91 *Mirror with Confetti*, 1970 Fig. 92 *Painting on Stretcher*, 1962

Do you own any works by American artists?

TAPIES: Yes, but only fairly small things: a painting by Motherwell, a gouache by Pollock and one by Tobey, a collage by Kline and something by Sam Francis.

To what extent do you take an interest in Cubism, which approaches the object in an intellectual, analytical spirit?

Fig. 93 *In the Form of a Leg*, 1968

124

TAPIES: The Cubists analysed the interior of the object, and I find that interesting. But in my work the idea is to evoke the real object. That's why my paintings are full of lines which blur and efface things. If I paint a nose, for example, and immediately see that it's not a real nose, I rub it out, but I leave in the residual marks. I have an increasing urge to get right inside things. Sometimes I break the object up by including cryptic symbols and letters, so that the viewer can't grasp the object merely by looking at it.

So you're equally concerned with the physical appearance of the object and the attempt to understand it in intellectual terms, via abstract signs and the written word.

CLAY SCULPTURES

In 1981 you made your first fireclay sculptures. Had you ever thought about using this material before?

TAPIES: I had been thinking about it for some time: the late Aimé Maeght had suggested on several occasions that I should try making some pottery. In Saint-Paul-de-Vence there was a potter's studio which was available for the use of artists who were under contract to the Maeght gallery. I hesitated at first, because I was already working with 'matter' in my paintings, and I didn't want to start doing sculpture with a different kind of material. So I resisted the suggestion for some time. But one day Eduardo Chillida rang me up and told me that fireclay was the ideal material for my work. He said I should start immediately. A few days later I went off to Vence and found that I really liked the material. What's your opinion? Do you think it suits my work?

Oh yes, very much so. It fits in perfectly with the hermetic character of your art, and with the whole idea of 'poor' art. In fact, it's possible that the clay sculptures are closer to your intentions than the paintings.

TAPIES: Did you go to my exhibition in Montmajour?

No, but I saw the catalogue, and I'd already seen some of the works at Hans Spinner's studio in the South of France.

TAPIES: The most important works were left out of the catalogue. They were the last things I made, and there was no time left to photograph them. It was only in the last few months before the exhibition that the ideas began to flow and the sculptures acquired real artistic power. I was working with really big formats.

I've seen The Large Foot.

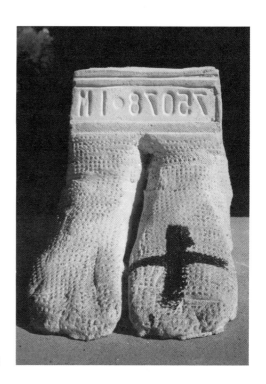

Fig. 94 *Two Feet*, 1985/86

TAPIES: Some of the pieces are even bigger, as big as this sofa. There's a sculpture of a bed, for example: I had to make it in four separate sections in order to get it in the kiln. And there's a bell which is big enough for a cathedral. I made that all in one piece [see fig. 95].

Are they solid?

TAPIES: You mean the bed and the bell? They're very heavy indeed.

Is it important to you that the weight gives the works the character of stone, that it corresponds to their massive, bulky appearance?

TAPIES: The material has to be solid because I use tools to shape it: I really attack it, and that would be impossible with thin materials. I even cut a piece out of the bell, so the viewer can see that it's solid.

In the Latin countries there is an established tradition of artistic ceramics, unlike in Germany, where ceramics are seen as mere pottery, as a craft rather than an art form. Have you ever had misgivings of that kind?

TAPIES: I'm sure that's just prejudice. I've never been bothered about that sort of thing. My intention, at least for the time being, is not to make pottery. I regard ceramics as a material for sculpture.

Do you, in fact, discriminate between fine and applied art? Do you regard them as separate?

TAPIES: My thinking has been influenced by the Japanese, who say that you can make art out of anything.

Having acquired an extensive experience of making fireclay sculptures, would you ever think of tackling another work as complex as the assemblage, covered with a huge glass dome, which you made as a homage to Picasso [see fig. 96]? Every time I've wanted to look at it, at least one of the panes of glass has been broken.

TAPIES: Yes, it's a rather complicated business. When the work was first installed people took to venting their aggression on it. But now they've got used to it, and I believe the panes are all intact at the moment. That's important, because the glass is not only there to protect the assemblage inside: it's an integral part of the sculpture, with water playing down the sides of the dome.

I've always tried to turn problems to my own advantage. When I'm painting, for example, I often find that I need a very thin brush, but there isn't one immediately to hand, so I use my finger instead. It's when I run into problems that I often discover the vital idea for the work. Perhaps I can't find the particular sort of paper I'm looking for, so I grab a piece of newspaper instead and start painting on that. I delight in difficulty. As I told you before, I prefer quick-drying paints, and I like to use worn-out brushes rather than new, good ones. People have given me sets of beautiful Japanese and Chinese brushes, but I never use them. I have a whole collection of brushes in every possible shape and size. I never touch them.

You see them as objets d'art.

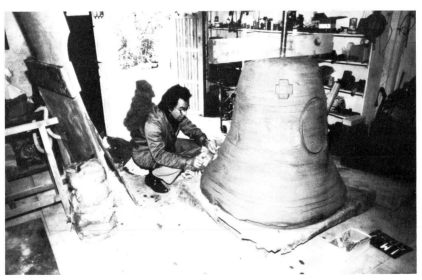

Fig. 95 Tapies working on *Large Bell*, 1986

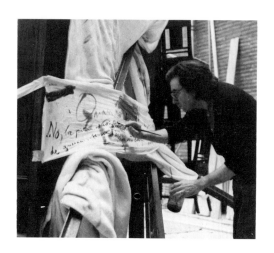

Fig. 96
Tàpies working on the
sculpture *Homage to Picasso*
in his Barcelona studio,
1982

TÀPIES: Yes, they're too precious for me.

In Hans Spinner's studio there are two big kilns: one of them is wood-fired and the other is electric. Is it possible to tell, by looking at the finished work, which of the kilns has been used?

TÀPIES: As a rule, yes. With the electric kiln the colours are always much lighter, because there's no smoke. But when I use the wood-fired kiln the smoke blackens the colours. The temperatures are also different, and the two kilns are used for different purposes. Painted ceramics are generally fired in the electric kiln, because they don't need high temperatures. The same applies to the small, fragile pieces: the things which are glazed. The wood-fired kiln is used for the big pieces and the solid fireclay sculptures, which would never fit in the electric kiln. I showed you that sculpture of the Buddha's tooth [fig. 97]. The colour is pure white, like porcelain. If that piece had been put in the wood-fired kiln, it would have turned out dark.

Does the big sculpture of the foot also refer to the Buddha?

TÀPIES: I've made two foot sculptures [see fig. 94]. Did you see the big slipper when you were at Hans Spinner's studio?

No, you made it sometime after my visit.

TÀPIES: And my inverted T? I've also made a stela in the shape of an upright letter T [fig. 98].

The stela is the same shape as the Saint Anthony cross.

TÀPIES: I didn't know that…

And I was absolutely convinced that the reason why you continually use that shape was that it combines the symbol of the cross with the initial of your surname and an allusion to your Christian name, Antoni.

TAPIES: That's really interesting, but I wasn't aware of the reference to the Saint Anthony cross. The T shape is often connected in my mind with the names Tàpies and Teresa. You've given me an idea there. Saint Anthony is a saint whom I find sympathetic. He was a Franciscan friar.

Bach alluded to his own name in his music and included various other symbols and cryptic references in his compositions.

TAPIES: Yes, I know.

I thought you were doing the same thing. From the very moment when you first started to experiment with ceramic sculpture, your painting became more transparent, and it took on a kind of emptiness. The object completely disappeared from the picture, although it remained central to your work as a sculptor. Has sculpture displaced the object from your painting?

TAPIES: Yes, that's possible, but I'm not sure to what extent. Whereas the paintings I've done over the last few years have a fluid, organic quality, the sculptures are heavy and earthy. Nevertheless, I think that some of the works I've done in clay have an element of movement, with organic curves. That's a subject I'm very interested in, and I think about it a great deal. In some of the objects I've tried to create a kind of synthesis between things that are rigid and immobile, and other things which are dynamic. This is all part of the mystery of life. Sometimes, everything seems static and fixed, and then, suddenly, things spring into motion.

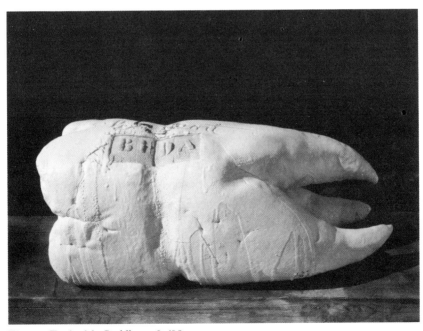

Fig. 97 *Tooth of the Buddha*, 1985/86

Fig. 98 *T-shaped Stela*, 1983

Perhaps I have a particular liking for synthesis. Whenever I see a conflict, I immediately start looking for a synthesis.

Is this tantamount to striving for harmony?

TAPIES: I don't know what harmony is. I don't know what beauty is either. I find it difficult to talk about harmony because, as you know, we artists loathe aesthetic concepts. I read Kant and see that beauty is supposed to be a value in itself, detached from all practical ends. That's something I simply don't understand. It's like people claiming to be apolitical, maintaining that they do things with no purpose, no goal. I don't believe that. Being apolitical is also a political stance. And it's just the same with beauty. I believe that art can and should be socially useful. Otherwise I'd give it up: I'd lose all interest in it.

THE ANTONI TAPIES FOUNDATION[38]

Have you made an effort to keep works which you consider particularly important, which have a personal significance for you?

TAPIES: No, I haven't. But fortunately, Teresa has held me in check. She insisted that we should keep a few pictures from each year, so we now [1987] have a fairly extensive collection which I can donate to the city of Barcelona.

130

So you've both been thinking about the Foundation for a long time?

TAPIES: In the mid-1970s we started thinking about setting up a museum and, with this in mind, we began keeping more works. In the first few years of my career we used to keep only three or four a year, but later the number increased: for the last fifteen years we've been keeping as many as ten.

Will you also be donating your private collection of works by other modern artists to the Foundation?

TAPIES: No, only my own work, together with my library: all the books concerned with art and aesthetic theory. The library also has a whole section devoted to Oriental art, something which is otherwise completely lacking in Barcelona. I think I can say, without fear of exaggeration, that the library will be a major gain for the city. We have also put together a substantial collection of books on China and Japan.

We have often talked about your collection of Asian art, which is part of your everyday surroundings. I've also seen your collection of art from various Latin and Central American cultures, but I've never seen any African art. Have you collected that as well?

TAPIES: Yes, I've bought a lot of African art, but I've never tried to collect it in a systematic way, because there's already a large private collection of African art in Barcelona: it isn't open to the public yet, but I know it will be going on permanent display sometime in the next few years. I collect things which are still rare in Barcelona: Japanese painting, for example. We have started to build up a small collection of Japanese art.

Art of which period?

TAPIES: There's a bit of everything. Our finances are limited, of course, so it's only a modest collection. There are about fifty paintings, together with a number of prints and examples of calligraphy. But I shall probably be lending these things to the Foundation for an exhibition, rather than donating them outright.

When you were looking for a place to house the Foundation, why did you choose a building in the commercial centre of the city? What made you opt for a building in the style of modernismo, *rather than one of the beautiful houses in the Gothic quarter of Barcelona? After all, that part of the city is very close to your heart and its walls bear the marks of the past, which are part of your own pictorial language.*

TAPIES: In the first place it was a question of what was available. The houses in the Gothic quarter are too small for a museum needing space for additional activities. The mayor of Barcelona offered me a house next door to the Picasso Museum, but that wasn't big enough either: it was

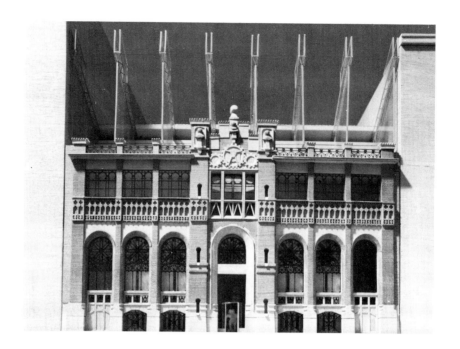

just an ordinary family house with small rooms, not at all the sort of building I had in mind for the Foundation. Anyway, the Gothic quarter isn't the real living heart of the city: quite the reverse, in fact. And there were the traffic problems, too. I thought about the possibility of commissioning an entirely new building far away from the city centre, following the example of the Miró Foundation, but there's no spare land left on the Montjuich: indeed, there's a ban on putting up new buildings because the area is now a public park. When I heard that the building designed by Lluis Domènech i Montaner was up for sale I began to think of the advantages attached to siting the Foundation in the city centre. Another reason why I liked the building was that I see it as a kind of symbol of Spanish *modernismo*. Montaner was a contemporary of Gaudí, and he introduced elements of modern engineering into architecture. He was Barcelona's first real modern architect.

I don't find the building modern at all. With all those Moorish, Egyptian and medieval elements, the style strikes me as eclectic and retrograde. Above the main door there's a tower, with a parapet running round the top [see fig. 52]. The spirit which presides over the building is medieval: there's a bust of a medieval knight with the visor on his helmet clamped shut, and the pilaster on the left-hand side of the tower is adorned with a bust of Dante.

TAPIES: But those are precisely the things I find interesting. I even quite like the allusions to primitive Gothic art. I don't see the building as a pastiche of the architecture of other ages and civilizations. To me it

Fig. 99 Model of the Antoni Tàpies
 Foundation, Carrer Aragó,
 Barcelona

Fig. 100 Entrance to the Antoni Tàpies
 Foundation before renovation

seems that all these different elements convey an enthusiasm for modernity. To a certain extent, they also fit in with present-day ideas, with Post-Modernism.

At all events, it's a very gloomy style.

TAPIES: But that's really very typical of Barcelona. The building stands for the spirit of an entire age. I think it's enormously significant. The late nineteenth century is a fascinating period in architecture, which stimulated new thinking in all other art forms as well.

To me the characteristic architectural style of Barcelona consists in the open, flowing, floral forms of Art Nouveau, which emerged ten years later. Up to now I had always thought that was what you meant when you spoke of modernismo. *Domènech's building is the very opposite of Art Nouveau: the forms are severe and geometric.*

TAPIES: Yes, it even has leaded windows [see fig. 100], which have medieval associations.

To me it looks like a church.

TAPIES: That's right, it's like a temple. Perhaps that was what particularly appealed to me about it.

Is the style perhaps based to some extent on the ideas of freemasonry? Gaudí was a freemason, too, wasn't he? I believe freemasonry was a very influential movement at the time.

TAPIES: I can't imagine Domènech i Montaner being a freemason. He was too much of a rationalist for that: his roots were in the progressive culture of the Left.

But surely the freemasons were progressive? Didn't they, too, oppose the power of the Church?

TAPIES: Yes, there is a progressive side to freemasonry, which is interesting. Freemasonry was one of the first things that Franco outlawed. He put it in the same category as Communism and Catalan nationalism.

Perhaps I would have preferred a building in the floral, Art Nouveau style, a piece of architectural *japanoiserie*; in fact, I'm sure I would, but there was nothing on the market at the time. We hunted around for ages. It really was very, very difficult to find something with an interior that would be suitable for a museum. This building isn't perfect, but it's interesting nevertheless.

Was your decision to buy the building influenced by the fact that your daughter-in-law is a member of the Domènech family?

TAPIES: Certainly that made us pursue the project more vigorously. When we heard that the building was for sale we gave it a lot of serious thought, but there were so many problems with the previous owner that I was in favour of dropping the whole thing. And then, one morning, Teresa came to me and said: we simply can't let the house go, because of its connection with our family. Our grand-daughter, little Teresa, bears the name Tàpies i Domènech. It's a stroke of fate: we have no choice but to carry on with the negotiations. If it hadn't been for Teresa's intervention, I'd have given up: it was all so complicated.

Do you intend to show the work of other artists at the Foundation?

TAPIES: There are quite a few things we want to do, but we don't want too much hectic activity. There's a room on the ground floor which is to be used for lectures, and concerts could also take place there. And then there's the library, offering facilities for the study of Asian art. Part of the building is to be given over to what I call the museum, where my own work will be on show. I want to stage a series of exhibitions devoted to other artists as well as to the various aspects of my art: my painting, my drawings and prints, my books and portfolios of graphics.

Could you say something about the aims of the Foundation?

TAPIES: We started off by thinking about what was lacking in Barcelona, and the main thing that was missing was Chinese and Japanese art. We wanted to promote the study of Asian art by establishing an extensive library of books on the subject and by staging various kinds of additional activities centred around the library, such as an exhibition of old books. On the same floor as the library there are several small rooms which

could be used for exhibition purposes. We also intended to set up a scholarship fund for students of Asian art, and to organize a series of lectures by experts from abroad, since there's nobody in Barcelona who teaches the subject. We had to start entirely from scratch.

Who will eventually look after the running of the Foundation? Your son?

TAPIES: As you know, Miquel is an art historian, and he will be co-ordinating the Foundation's activities.

As its director?

TAPIES: We still don't know whether the Foundation will have a director. The restoration work on the building isn't finished yet, so we've still got plenty of time to think about the matter. There is a small management committee made up of members of my family and staff, together with representatives of the city administration and the government of Catalonia. And for the time being, as long as my health permits, I intend to chair the committee myself, so we don't need a director.[39] I want to keep the Foundation's activities on a fairly low-key level; I'm not trying to set up in competition with the Centre Pompidou! The Miró Foundation, which recently added an extension to its main building, has expanded its activities. It has to do that in order to attract visitors, because it's so far from the city centre. They've started doing all kinds of things, putting on puppet theatre shows, bringing in clowns to entertain the children, and so on. I don't want that sort of thing at the Tàpies Foundation. My aim is to teach the public something about the origins of modern art and its role in society, and to point out the links between modern art and the art of the Far East. It's impossible to understand Abstract Expressionism without referring to Oriental calligraphy, the expressive gesture, the brushstroke. There are similar examples to be found in music. You can't appreciate John Cage's music for prepared piano unless you've heard the gamelan music of Bali and Java.

Do you know the music of Giacinto Scelsi? The first time you hear it, it sounds exactly like Indian music. India and the Far East have had a crucial influence on modern art and music. It's an influence which is partly hidden, moving along subterranean channels, as it were. But at the time of the Art Nouveau movement the influence was far more evident. The West copied Japanese forms. All those floral forms – they were simply copied. Nowadays, though, it seems to me that the main influence is in the area of philosophy, which is the basis of all these forms: the philosophical intentions have become more important than the forms themselves. You must get hold of a record of Scelsi's music. One of the things he has written is a one-note concerto, just a single note played over and over again by a large symphony orchestra. It's fantastic. You think you're listening to a piece of Indian music. Early Indian music is also very drawn-out and repetitive, and very beautiful.

When I visited Edgar Varèse for the first time in New York I remember he showed me his collection of Tibetan bells. He knew the exact significance of all the various bells and gongs.

It always surprises me that you've never actually been to the East.

TAPIES: I don't think my spiritual preparation is complete yet, but I know I'll have to go there sometime.[40] I have a whole collection of literature on Zen temples. Perhaps I'll have an exhibition there which will give me an opportunity to go. In my mind I have a kind of ideal image of China and Japan.

Do you have any sort of contact with Japanese people in Barcelona?

TAPIES: There are quite a number of Japanese people living in Barcelona. Teresa knows some of them. She has read a certain amount of Japanese literature, and she has even studied Ikebana with a Japanese teacher.

What about you?

TAPIES: We have a number of Japanese acquaintances, including painters, writers and an art critic you may have heard of: his name is Tono. We've known him for some time.

During my Surrealist period I was in regular contact with a Japanese poet called Takigutshi – he's dead now. We even produced a book together, a large-format book with lithographs to accompany his poetry.[41]

Is that the only work which directly connects your art with that of the Far East?

TAPIES: Yes, it's the only one.

I once showed a book about your work to a Japanese and asked him to what extent the Eastern ideas which you try to put across in your art are apparent to Oriental eyes. He said that Zen meant silence, and that was what you painted.

TAPIES: People who have found true knowledge fall silent. If I were a philosopher I would stop painting; I'd do nothing at all. That would be the silence of Zen. The only thing to do is to carry on searching for the light: I haven't found it yet, and that's why I paint.[42]

1 *Mohesin:* to become one with the self or to achieve identity with the absolute (from the Greek μύειν: to close the eyes or lips).

2 Albert Einstein once wrote: 'The deepest and most sublime feeling of which we are capable is the experience of the mystical. It is from this alone that true science develops. If a person has lost the capacity to experience this sensation, the capacity for wonderment and reverence, then his soul is already dead.' Quoted in *Die deutschen Romantiker*, Stuttgart and Salzburg, n. d., vol. 1, p. 37.

3 The letter x is an ancient symbol of opposition and predestination, and it frequently carries connotations of this kind in the work of Tàpies – for example, in *Sardana* (fig. 33), where the footprints form a circle with a large x in the centre. The *sardana*, a traditional round dance, was one of the few Catalan folk customs not to have been outlawed by the Franco regime. The Catalans used it as a means of expressing their striving for autonomy and their opposition to the central government in Madrid.

4 Kakuzo Okakura, *Das Buch vom Tee*, Frankfurt am Main, 1977. On p. 49 Okakura writes: 'We ourselves are the masterpiece, just as we are the real work of art.'

5 The basic work of Lao-Tse's Taoist teaching.

6 Alan Wilson Watts (1915–1973): English-born thinker and writer. His principal works include *The Spirit of Zen* (1936), *The Legacy of Asia and Western Man* (1937), *The Meaning of Happiness* (1940), *The Theologia Mystica of St. Dionysus* (1946), *This Is It* (1960), *Psychotherapy East and West* (1961) and *Beyond Theology* (1964).

7 This volume has since appeared: see following note.

8 Two volumes have now apppeared: Anna Augusti, *Tàpies: The Complete Works*, vol. 1: *1943–1960*, vol. 2: *1960–1968*, Barcelona, 1988, 1990. Volume 3, covering the years 1969 to 1975, will be published in autumn 1991.

9 Zen (Japanese), also known as *ch'an* (Chinese): a mystical Buddhist sect.

10 Departing from conventional practice, Tàpies spells *Deu*, the Catalan word for 'God', with a small d.

11 Rudolf Otto (1867–1937): theologian and religious scholar. His principal works are *Das Heilige* and *Das Gefühl des Überweltlichen*.

12 Vedanta (Sanskrit: end): the conclusion of the Vedas, the earliest sacred literature of India. The revelations and insights contained in the Vedanta, which deal principally with the relationship between the individual self (*atman*) and the absolute (*Brahman*), were summed up by Badarayana in his *Vedanta Sutra*, which forms the basis of Vedanta philosophy. In the introduction to the chapter on the *Vedanta Sutra* in his book *Indian Philosophy* (1955) Radhakrishnan writes: 'Of all the Hindu systems of thinking, Vedanta philosophy is the one which is most intimately connected with Indian religion and, in one way or another, it continues to influence the ideas of all present-day Hindu thinkers.' See *Lexikon der östlichen Weisheitslehren*, Berne, Munich and Vienna, 1986.

13 Yoga (Sanskrit: yoke): the search for union with the supreme being. In Hindu philosophy there are several different systems of yoga. The system most commonly known in the West is Hatha yoga, which is based on a combination of physical exercises and breathing techniques. In India, however, this type of yoga is regarded as no more than a preparation for the spiritual forms of yoga, which employ various techniques of meditation. Yoga is not seen as a specifically Indian prerogative: it is a general path to divine enlightenment, and anyone with an interest in mystical experience – for example, Christian mystics or the American Indian shamans – is deemed a yogi. Hence, the tantric practices of Tibetan Buddhism are also regarded as a form of yoga. See *Lexikon der östlichen Weisheitslehren*.

14 *Koan* (Japanese: a public proposal or plan): originally a Chinese term meaning 'legal precedent'; in Zen Buddhism a paradoxical question given to students which illustrates the Zen experience. The practice originated in the

tenth century. Since the question cannot be solved by rational means, it exposes the limits of conceptual understanding and demonstrates the need to transcend rational thought, pointing the way towards a world which lies beyond logical contradiction and dualistic forms of thinking. See *Lexikon der östlichen Weisheitslehren*.

15 A term in Pali Buddhism. Pali is the language in which the sacred texts of the Indian Buddhists are written.

16 Antoni Tàpies, *Memòria personal*, Barcelona, 1977.

17 Tàpies's remark refers to the art of the 1970s.

18 See p. 38.

19 *Maya* (Sanskrit): illusion.

20 The full sentence reads: 'Your act is always set down on paper, since meditation which leaves no trace does not endure nor does it stimulate the senses to make those few vehement gestures which you sought in vain.'

21 *Atman* (Sanskrit): the self or soul.

22 See n. 17, p. 60.

23 Troubadour poetry largely died out towards the end of thirteenth century. In Catalonia, however, its influence persisted, as can be seen in the poetry of Ausiàs March (b. 1397, Gandia – d. 1459, Valencia), one of the foremost representatives of Catalan literature, whose work was inspired by the Provençal troubadours and the poetry of Petrarch. Similar influences can be seen in the poetry of his contemporary Jordi de Sant Jordi (see n. 13, p. 59), whose vocabulary is partly Provençal, unlike that of March, who wrote entirely in Catalan.

24 From the ninth century onwards, Catalonia was effectively an independent country, ruled by counts. In 1137, when Count Ramon Bereguer IV married the Queen of Aragon, Catalonia and Aragon were united under the same ruler; ever since, the Catalans have been involved in a continual struggle against one form or another of central government. Catalonia retained a measure of autonomy until the end of the War of the Spanish Succession in 1714, when its privileges were abrogated and it became a Spanish province.

25 Jacint Verdaguer i Santaló (1855–1886). See n. 13, p. 59.

26 Ibid.

27 Ibid.

28 Ibid.

29 Ibid., p. 58.

30 Ibid., p. 59.

31 *Haiku*: a Japanese poem in three lines of five, seven and five syllables.

32 See n. 15.

33 In 1986 Tàpies published a text on the poetic objects of Brossa: 'Les arts d'en Brossa', in *Joan Brossa*, exhibition catalogue, Fundació Miró, Barcelona.

34 Hans Namuth and Georg Reisner, *Spanisches Tagebuch 1936*, Berlin, 1986. The book is a collection of photographs and texts dating from the first months of the Spanish Civil War.

35 Alexander Mitscherlich, *Sinnieren über Schmutz*, with eight lithographs by Antoni Tàpies, St Gallen, 1976–78.

36 In March 1966 the Capuchin monks of Sarrià opened the doors of their monastery to a group of students who were trying to establish a democratic student union at the University of Barcelona. The students were supported by a large number of university teachers, intellectuals and prominent artists. Five years later, in March 1971, Tàpies was ordered to pay a fine of 200,000 pesetas for attending the illegal meeting at the monastery.

37 Andreas Franzke, '*Skulpturen und Objekte' von Malern des 20. Jahrhunderts*, Cologne, 1982.

38 It should be remembered that the conversations printed here took place before the Foundation was opened in June 1990.

39 Miquel Tàpies has been director of the Foundation since it was opened in June 1990.

40 Tàpies went to Japan in October 1990, when he was awarded the Imperial Prize by the Japanese Art Association.

41 *Llambrec material*, Barcelona, 1975.

42 C. G. Jung wrote: 'Eastern mystical practices have the same goal as Western mysticism: there is a shift of emphasis from the ego to the self, from man to God. Thus the ego and man vanish: they are absorbed into the self and into God. ... As a clearly defined religious and ethical aim, the formula self=God points to the dissolution of the self in the *atman*. ... This, of course, also applies to Christian mysticism, which is fundamentally similar to Eastern philosophy.' C. G. Jung, 'Über den indischen Heiligen', preface to Heinrich Zimmer, *Der Weg zum Selbst*, Zurich, 1944, p. 19 ff.

Biographical Notes

(Details of exhibitions in private galleries are given only up to 1962, the year of Tàpies's first museum retrospectives)

1923

Born in Barcelona, 13 December. Tàpies's father was a solicitor; his mother came from a Barcelona family of booksellers.

1926

Attends nursery school at the College of the Sisters of Loreto, Barcelona.

1928

Attends the German School, Barcelona.

1931

Change of school: attends the Colegio Balmes run by the Order of Christian Schools. Tàpies changes school again several times in the course of the next few years.

1940

Schooling interrupted several times by illness.

1942

A heart and lung complaint necessitates an extended stay in a succession of sanatoria, at Puig d'Olena, Puigcerda and La Garriga, in the mountains. Does a large number of drawings and copies paintings by Van Gogh and Picasso.

1943

Begins to study for a law degree at Barcelona University.

1944

Studies for two months at the Nolasc Valls Academy of Art.

1945

Paints his first pictures with thick impasto and begins to make Dada-influenced collages using a variety of materials, including cardboard, string, newspaper and toilet paper (see fig. 19, 20, 25).

1946

Abandons study of law and henceforth devotes all his energies to art. Establishes his first studio in Carrer Jaime I in the Gothic quarter of Barcelona.

1947

Becomes acquainted with the Catalan poet Joan Brossa and the collector Joan Prats, a friend of Miró.

1948

Together with a group of young painters and poets from Barcelona, Tàpies founds the magazine *Dau al Set* (see fig. 15). He takes part in his first exhibition: two of his pictures are shown at the October salon in Barcelona. One of them, *Collage of the Crosses*, created the previous year, arouses considerable controversy.

1949

Takes part in exhibitions in Barcelona (with the groups known as Cobalto 49 and Club 49) and Madrid (at the Salon de los Once).

Working in the studio of Enric Tomo, Tàpies creates his first etchings. Paints his first Surrealist pictures, which are clearly influenced by Miró, Klee, Ernst and Tanguy (see plate 1).

Beginning of his acquaintance with the Catalan poet J. V. Foix, who buys one of Tàpies's pictures.

1950

First one-man exhibition at the Galeria Laietanes, Barcelona (28 October – 10 November). Joan Brossa publishes 'Oracle for Antoni Tàpies' in the catalogue, which doubles as an issue of *Dau al Set*.

Tàpies spends a year in Paris on a French government scholarship. From this point onwards he pays frequent visits to France.

Takes part in the 'Carnegie International' exhibition at the Carnegie Institute, Pittsburgh.

1951

Visits Picasso in Paris. Break-up of the *Dau al Set* group, followed by a final retrospective at the Sala Caralt, Barcelona. Exhibition of work by Tàpies at the Casino de Ripoll, Barcelona (6–15 August).

1952

Second one-man exhibition at the Galeria Laietanes, Barcelona (3–23 May). Takes part in the 26th Venice Biennale.

1953

One-man exhibition at the Museo Municipal, Mataró, Barcelona (11–25 January). First one-man exhibition in the USA at Marshall Field & Company, Chicago (1 April – 1 May). One-man exhibition at the Biosca gallery, Madrid (21 April – 5 May). Travels to New York for the opening of his exhibition at the Martha Jackson Gallery (28 October – 14 November) and signs a contract with the gallery.

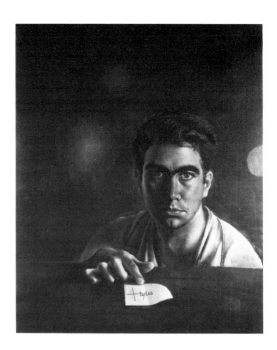

Fig. 101 *Self-Portrait*, 1950

First thick impasto paintings on the themes of walls and graffiti (see fig. 30, 31); the colours take on an earthy quality. Tàpies returns to the technique of collage, using discarded materials.

1954

Third one-man exhibition at the Galeria Laietanes, Barcelona (1–15 May). Martha Jackson opens the way for Tàpies to participate in several exhibitions in the USA.

In Paris Tàpies meets the writer Michel Tapié, who takes a keen interest in his work. Marriage to Teresa Barbra Fábregas.

For the second time Tàpies shows a number of works at the Venice Biennale.

1955

Group exhibitions in Stockholm, Barcelona and Paris. One-man exhibitions at the Sala Gaspar, Barcelona (March), and the Sur Galeria de Arte, Santander (November).

Wins the Republic of Colombia Prize at the third Hispano-American Biennale, Barcelona. Tàpies's contribution to the exhibition causes a major scandal.

1956

One-man exhibitions at the Galerie Stadler, Paris (20 January – 16 February), and the Sala Gaspar, Barcelona (November).

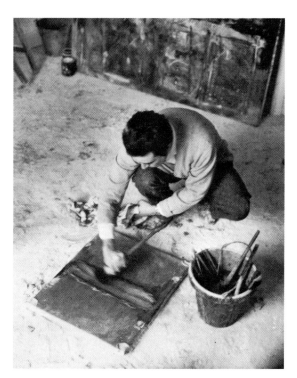

Fig. 102 Tàpies working in his Barcelona studio

Tàpies becomes interested in Eastern philosophy and begins to study the Vedanta, yoga, Tantrism, Buddhism and Zen.

1957

Premio Lissone (competition for young painters), Milan. One-man exhibitions at the Martha Jackson Gallery, New York (21 February – 14 March), the Galerie Stadler, Paris (14 June – 13 July), and the Galerie Schmela, Düsseldorf (November – December). The last of these is Tàpies's first show in Germany.

1958

One-man exhibition at the Galleria dell'Ariete, Milan (May – June). Tàpies is given a room to himself at the 29th Venice Biennale, where he wins the UNESCO Prize endowed by the David Bright Foundation, Los Angeles. First Prize, 'Carnegie International', Carnegie Institute, Pittsburgh. Exhibition in Osaka.

1959

Second visit to the USA, where he meets Franz Kline, Willem de Kooning, Robert Motherwell and Hans Hofmann.

First portfolio of lithographs published by the Sala Gaspar, Barcelona.

One-man exhibitions at the Gres Gallery, Washington, the Martha Jackson Gallery, New York (24 February – 21 March), and the Galerie Stad-

ler, Paris (14 April – 11 May). Group exhibitions: '4 Maler' (Kunsthalle, Berne), '15 Maler in Paris' (Kölnischer Kunstverein, Cologne), 'documenta II' (Kassel), 'European Art Today' (a travelling exhibition shown at several American museums).

Three pictures commissioned by the city of Barcelona.

Tàpies tends increasingly to use second-hand, commonplace materials.

1960

Ministry of Foreign Affairs Prize, International Biennale of Graphics, Tokyo. One-man exhibitions at the Sala Gaspar, Barcelona (February), the Martha Jackson Gallery, New York (22 March – 17 April), and the Blanche Gallery, Stockholm (October – November). Group exhibitions: 'New Spanish Painting and Sculpture' (Museum of Modern Art, New York), 'Before Picasso, after Miró' (Solomon R. Guggenheim Museum, New York), 'Neue Malerei: Form, Struktur, Bedeutung' (Städtische Galerie im Lenbachhaus, Munich).

Buys a country house in Campins.

1961

Third trip to the USA. Accompanied by Michel Tapié, visits the composer Edgar Varèse.

One-man exhibitions at the Sala Gaspar, Barcelona (February), the Gres Gallery, Washington (15 March – 8 April), the Galerie Rudolf Zwirner, Essen (April), and the Galerie Stadler, Paris (20 June – 20 July). Group exhibitions: 'Arte e contemplazione' (Palazzo Grassi, Venice) and 'Paris: Carrefour de la peinture 1945–1961' (Stedelijk Van Abbemuseum, Eindhoven).

1962

Werner Schmalenbach organizes Tàpies's first retrospective, at the Kestner-Gesellschaft in Hanover (14 February – 1 April). Tàpies attends the opening of the exhibition and then travels to New York for the opening of his retrospective at the Solomon R. Guggenheim Museum (March – April). A further retrospective is held at the Kunsthaus, Zurich (29 April – 3 June). Work commissioned for the library of the Handelshochschule in St Gallen. One-man exhibitions at the Museo Nacional de Bellas Artes, Caracas, and the Galleria Il Segno, Rome (7–30 March).

1963

Art Club Prize, Providence, Rhode Island. One-man exhibitions at the Phoenix Art Center, Phoenix, Arizona, the Pasadena Art Museum, Pasadena, the Felix Landau Gallery, Los Angeles, the Martha Jackson Gallery, New York, the Galerie Berggruen, Paris, the Galerie im Erker, St Gallen, and the International Center of Aesthetic Research, Turin (November).

Fig. 103 Tàpies. Barcelona, 1962

Tàpies moves into his new house and studio at 57 Carrer Saragossa in Barcelona (see fig. 1, 104).

1964

Guggenheim Foundation Award, New York. Tàpies is given a room to himself at the third 'documenta' in Kassel, where he exhibits three large

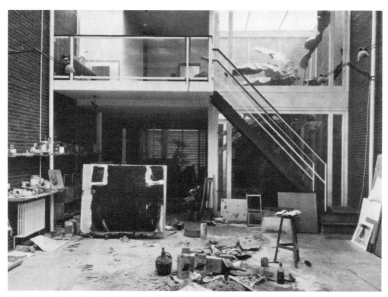

Fig. 104 Tàpies's studio at 57 Carrer Saragossa, Barcelona

paintings. Gallery exhibitions in Cologne, Rome, Paris, Toronto, Stockholm, Barcelona and Montreal. Visits Rome and southern Italy.

1965

One-man exhibition at the Institute of Contemporary Arts, London (3 June – 3 July).

Gallery exhibitions in Solothurn, Munich, St Gallen and Barcelona.

1966

Grand Prix, 6th Menton Biennale, France.

Tàpies is arrested and prosecuted for attending a prohibited assembly at the Capuchin monastery of Sarrià in Barcelona. The monks had opened up the monastery to a group of students who were trying to set up a democratic union at the university.

Gold Medal, 15th International Congress of Art Critics, Historians and Artists, Rimini. The citation speaks of the 'moral power' of Tàpies's work.

Gallery exhibitions in Madrid, Paris, Cannes and Stockholm.

1967

Grand Prize, Seventh International Biennale of Graphics, Ljubljana. Exhibition of Tàpies's entire graphic oeuvre at the Kunstmuseum, St Gallen (3 June – 23 July). Gallery exhibitions in New York and Paris (at the Galerie Maeght, with which Tàpies signs a contract).

1968

Travels to Vienna to attend the opening of a retrospective, selected by Werner Hofmann, at the Museum des 20. Jahrhunderts (16 March – 24

Fig. 105 *Fans II, III*, 1968

April). Retrospectives at the Kunstverein, Hamburg (May – June), and the Kunstverein, Cologne (19 July – 25 August). Gallery exhibitions in Düsseldorf, New York and Paris. Tàpies does a series of three paintings in ink on cloth to hang over windows at the Capuchin monastery of Sion in Switzerland (see fig. 105).

1969

Graphics retrospective at the Kunstverein, Kassel (27 February – 30 March). Gallery exhibitions in Munich, Paris, Toronto and Barcelona.

1970

Begins work on a large 'combine' painting for the foyer of the theatre in St Gallen, Switzerland.

Gallery exhibitions in Milan, New York, Barcelona, Lausanne, Stockholm and Baden-Baden.

In December Tàpies and Miró attend a meeting of Spanish intellectuals at the monastery of Montserrat to discuss a court case recently brought against a group of Basque nationalists.

1971

Gallery exhibitions in London, Rome, Zurich, Balstahl (Switzerland), Cologne, Palma/Majorca, Malmö and Barcelona.

Tàpies installs his painting in the foyer of the theatre in St Gallen (fig. 51); the work occasions a public outcry.

1972

Rubens Prize of the town of Siegen (Germany), where an exhibition of Tàpies's work is held in the Städtische Galerie im Haus Seel (26 June – 30 July). Further exhibitions at the Galerie Maeght, Paris, and the Museo Municipal Mataró, Barcelona (12–24 February).

1973

Retrospective of pictures and objects, 1945–73, at the Musée d'Art Moderne de la Ville de Paris (25 May – 2 September). Retrospectives at the Musée Rath, Geneva (5 October – 18 November), and the Palais des Beaux-Arts, Charleroi (8 December – 13 January 1974). Gallery exhibitions in Malmö, Barcelona, Los Angeles, Seville, Bonn, New York and Madrid.

1974

Retrospectives at the Louisiana Museum, Humblebaeck (2 January – 10 March), the Nationalgalerie, Berlin (3 April – 3 June), and the Hayward Gallery, London (27 June – 1 September).

Gallery exhibitions in Düsseldorf, Paris, Mexico City, Göteborg, Toronto and New York.

1975

Gallery exhibitions in Madrid, Barcelona, Palma/Majorca, Paris, Geneva, Seville, The Hague, Zurich, Los Angeles, Basle and New York.

1976

Retrospectives at the Fondation Maeght, Saint-Paul-de-Vence (10 July – 30 September), the Seibu Museum of Art, Tokyo (27 August – 19 September), and the Fundació Joan Miró, Barcelona (22 October – 5 December).

Gallery exhibitions in Madrid, Paris, Barcelona, Geneva, Munich and Boston.

1977

Retrospective shown at several museums in the USA and in Canada: the Albright-Knox Art Gallery, Buffalo, New York (22 January – 6 March); the Museum of Contemporary Art, Chicago (13 March – 1 May); the Marion Koogler McNay Art Institute, San Antonio, Texas (29 May – 31 July); the Des Moines Art Center, Des Moines, Iowa (29 August – 12 October); and the Musée d'Art Contemporain, Montreal, Quebec (27 October – 27 November). Gallery exhibitions in Granada, Cologne, Barcelona and Madrid.

1977/78

Retrospective of drawings, watercolours, gouaches and collages, 1944–76, shown at the Kunsthalle, Bremen (4 September – 23 October 1977), the Staatliche Kunsthalle, Baden-Baden (12 November 1977 – 8 January 1978), and the Kunstmuseum, Winterthur (27 January – 12 March 1978).

1978

Retrospective of works on paper at the Musée Municipal de l'Abbaye Sainte Croix, Les Sables d'Olonne (15 April – 11 June). Exhibition of pictures and prints at the Centre d'Etudes Catalans, Paris (9 May – 30 June). Exhibition of etchings and lithographs at the Hastings Gallery in the Spanish Institute, New York (15 November – 6 January 1979). Gallery exhibitions in Valencia, Brasilia, New York, Madrid, Düsseldorf, St Gallen, Barcelona and Hamburg.

1979

Gallery exhibitions in Amsterdam, Cologne, Paris, Karlsruhe, Mexico City and Stuttgart.

Elected honorary member of the Akademie der Künste, West Berlin.

1979/80

Retrospective of pictures and objects, 1948–78, shown at the Badischer Kunstverein, Karlsruhe (25 September – 11 November 1979), the Kunst-

Fig. 106 Tàpies at the opening of his exhibition at the Galerie Lelong,
 Zurich, in 1984

halle, Kiel (29 January – 9 March 1980), and the Neue Galerie der Stadt,
Linz (13 March – 3 May 1980).

1980

Retrospectives at the Museo Español de Arte Contemporáneo, Madrid
(May–August), and the Stedelijk Museum, Amsterdam (25 September –
16 November). Group exhibitions: 'Schrift und Bild' (Basle), 'Zeichen
des Glaubens' (Berlin) and 'Umanesimo, disumanesimo nell'arte
europea 1890–1980' (Florence). Gallery exhibitions in Tarragona, Las
Palmas/Gran Canaria, Rome, Salzburg, Barcelona, Amsterdam, Val-
ladolid and Zurich.

1981

Does the preliminary sketches for a monument to Picasso, commis-
sioned by the city of Barcelona. In Saint-Paul-de-Vence, working under
the technical supervision of Hans Spinner, he makes his first clay sculp-
tures.

Gold Medal for Fine Arts, Ministry of Culture, Madrid, personally pre-
sented by King Juan Carlos.

Honorary doctorate, Royal College of Art, London.

Retrospective during the summer months at the Fondation du Château
de Jau, Cases de Pène. Gallery exhibitions in Mexico, Barcelona, Tokyo,
Düsseldorf, Madrid, St Gallen, Perpignan, Lindau, Zurich, New York

and San Francisco. Several works by Tàpies are included in the exhibition 'Paris – Paris 1937–1957' at the Centre Pompidou, Paris (28 May – 2 November).

1982

Retrospective at the Palacio de la Lonja, Saragossa (26 February – 25 March). Exhibition of works, 1946–82, at the Scuola Grande di San Giovanni Evangelista, Venice (as part of the Biennale).

Wolf Foundation Prize, Jerusalem (with Marc Chagall).

Gallery exhibitions in Lausanne, Brussels, Stuttgart, New York, Paris, Barcelona and Palma/Majorca.

1983

In the spring Tàpies's monumental sculpture *Homage to Picasso* is unveiled in Barcelona. An exhibition of sketches and other documents connected with the monument is held at the University of Barcelona (7 April – 18 May).

Exhibitions at Sénanque Abbey, Gordes/Vaucluse (9 July – 29 August), and the Palau dels Comtes de Centelles, Barcelona (27 August – 9 September). Included in 'Hommage à Miró' at the Städtische Galerie, Prinz-Max-Palais, Karlsruhe (24 September – 13 November).

Exhibition 'Tàpies intim' at the Städtische Galerie, Prinz-Max-Palais, Karlsruhe (24 September – 13 November). Exhibition of posters and of designs for book jackets and record sleeves at the Fundació Joan Miró, Barcelona (December 1983 – February 1984). Gallery exhibitions in Bochum, Zurich and Barcelona.

With the help of Joan Gardy Artigas, Tàpies makes a mosaic for the Plaça Catalunya in San Boi de Llobregat (see fig. 84, 85) and is honoured with a gold medal by the Generalitat de Catalunya. Awarded the Rembrandt Prize of the FVS Foundation, Hamburg. Elected a member of the French Ordre des Arts et Lettres.

Assisted by Hans Spinner, Tàpies makes a new series of clay sculptures (see plates VII, VIII and fig. 40, 44, 45, 57, 98), working in the studio of Joan Gardy Artigas in Gallifa, near Barcelona.

1984

Awarded the Peace Prize of the Spanish United Nations Society.

Exhibition at the Museo Municipal de San Telmo, San Sebastian (March–April). Travels to Berlin for the opening of his exhibition at the Galerie Brusberg. Exhibition in connection with the Salon d'Automne, Lyon (5 October – 8 November). Gallery exhibitions in Cologne, Stockholm, Berlin, New York, Zurich (see fig. 106), Barcelona, Tarragona, Frankfurt, Madrid and Paris.

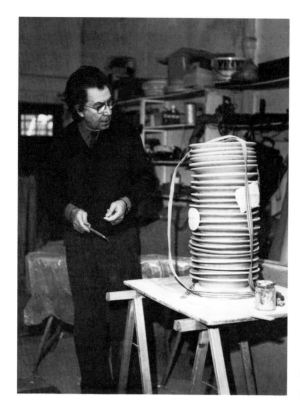

Fig. 107
Tàpies in Hans Spinner's
studio at Grasse, 1986

1985

Travels to Milan for the opening of the exhibition 'Tàpies Milano' at the
Palazzo Reale, which is complemented by four further shows in private
galleries (8 May – 30 June). Exhibitions at the Museum voor Moderne
Kunst, Brussels (in connection with the Europalia: 26 September – 22
December), and the Centre Municipal de Cultura, Alcoi/Valencia
(November–December). Makes a further series of clay sculptures (see
fig. 11, 43, 66, 94, 97) at Hans Spinner's studio in Opio, near Grasse (see
fig. 39, 107, 108).

Prizewinner at the International Triennale for Original Coloured Prints
in Grenchen, Switzerland. In December Tàpies is awarded the Prix
national de peinture by the French government. Elected member of the
Royal Academy of Arts, Stockholm.

1986

Travels to Vienna for the opening of an exhibition of thirty-one paintings
and four sculptures at the Künstlerhaus. The exhibition is subsequently
shown at the Stedelijk Van Abbemuseum, Eindhoven (22 March – 27
April). Exhibition of poster designs at the Sala de Exposiciones de la
Obra Social, Léon (24 April – 6 May). Exhibition of clay sculptures and

reliefs at Montmajour Abbey, Arles (6 July – 13 October). Gallery exhibitions in Barcelona, Madrid, New York, St Gallen, Los Angeles and Paris.

1987

In January Tàpies signs co-operation agreements with the Generalitat de Catalunya and the city of Barcelona to establish the Fundació Antoni Tàpies. The Foundation is to be housed in the former premises of the publishing firm of Montaner i Simon in Carrer Aragó (see fig. 52, 99, 100).

In May and June Tàpies produces a further series of ceramic works at Hans Spinner's studio in Opio, near Grasse.

1988

Awarded an honorary doctorate by the University of Barcelona. Retrospectives in Barcelona, Palma/Majorca and Marseilles. His graphic work is the subject of a travelling retrospective exhibition in the USA.

1989

Elected honorary member of the Künstlerhaus, Vienna. Retrospective exhibition at the Kunstsammlung Nordrhein-Westfalen in Düsseldorf.

1990

Unveiling of the monumental sculpture *Cloud and Chair* on top of the building housing the Antoni Tàpies Foundation. The Foundation initiates its programme of public activities.

Fig. 108
Tàpies in the garden of
Hans Spinner's studio at Grasse,
1986

Awarded honorary doctorates by the University of Glasgow and the University of the Baleares, Palma/Majorca. Receives the Premio Príncipe de Asturias de las Artes in Oviedo and the Imperial Prize in Tokyo.

One-man exhibitions in Oviedo and at the Centro de Arte Reina Sofiá in Madrid.

Acknowledgments

The author and publishers wish to thank Miquel Tàpies for his help in compiling the Biographical Notes and the Selected Bibliography, and in supplying photographs for the illustrations. We are also grateful to Marie-Charlotte Catoir de Garcia and Jorge Garcia-Petit for their advice on problems of translation from Catalan.

Appendix

LIST OF ILLUSTRATIONS

(Details of ownership are given only when the present whereabouts of a work could be ascertained beyond doubt)

Writings by the artist

La pràctica de l'art, Barcelona/Esplugues de Llobregat, Ediciones Ariel, 1970. French: trans. Edmond Raillard, foreword Georges Raillard, *La pratique de l'art*, Paris, Editions Gallimard, 1974. German: trans. Gret Schib, Josep Grau and Kurt Leonhard, *Die Praxis der Kunst*, St Gallen, Erker-Verlag, 1976. Italian: trans. Perla Avegno, *L'arte contro l'estetica. La pratica dell'arte*, Bari, Edizioni Dedalo, 1980.

L'art contra l'estètica, Barcelona/Esplugues de Llobregat, Editorial Ariel, 1974. French: trans. Edmond Raillard, *L'art contre l'esthètique*, Paris, Editions Galilée, 1978. German: trans. Eberhard Geisler, *Kunst kontra Ästhetik*, St Gallen, Erker-Verlag, 1983. Italian: trans. Perla Avegno, *L'arte contro l'estetica. La pratica dell'arte*, Bari, Edizioni Dedalo, 1980. Spanish: trans. Joaquim Sempere, *El arte contra la estètica*, Esplugues de Llobregat, Barcelona, Ediciones Ariel, 1978.

Memòria personal: Fragment per a una autobiografia, Barcelona, Editorial Crítica, 1977. French: trans. Edmond Raillard, *Mémoire: Autobiographie*, Paris, Editions Galilée, 1981. Italian: trans. Perla Avegno, *Autobiografia*, Venice, Marsilio Editori, 1982. Spanish: trans. Javier Rubio and Pere Gimferrer, *Memoria personal: Fragmento para una autobiografía*, Barcelona, Editorial Seix Barral, 1983.

La realitat com a art, Barcelona, Editorial Laertes, 1982.

Per un art modern i progressista, Barcelona, Editorial Empúries, 1985.

Selected Essays, trans. Antoni Kerrigan, Eindhoven, Van Abbemuseum, 1986. Contains English translations of extracts from *La pràctica de l'art*, *L'art contra l'estètica* and *Per un art modern i progressista*.

Books illustrated by the artist

Brossa, Joan, *El pa a la barca*, Barcelona, Sala Gaspar, 1963.

Brossa, Joan, *Novel.la*, Barcelona, Sala Gaspar, 1965.

Dupin, Jacques, *La nuit grandissante*, St Gallen, Erker-Presse, 1968.

Brossa, Joan, *Frègoli*, Barcelona, Sala Gaspar, 1969.

Brossa, Joan, *Nocturn matinal*, Barcelona, La Polígrafa, 1970.

Bouchet, André du, *Air*, Paris, Maeght, 1971.

Brossa, Joan, *Poems from the Catalan*, Barcelona, La Polígrafa, 1973

La clau del foc, comp. and intro. Pere Gimferrer, Barcelona, La Polígrafa, 1973.

Tàpies, Antoni, *Cartes per a la Teresa*, Paris, Maeght, 1974.

Daive, Jean, 〔, Paris, Maeght, 1975.

Jabès, Edmond, *Ça suit son cours*, Montpellier, Fata Morgana, 1975.

Takiguchi, Shuzo, *Llambrec material*, Barcelona, La Polígrafa, 1975.

Mitscherlich, Alexander, *Sinnieren über Schmutz*, St Gallen, Erker-Presse, 1976-78.

Alberti, Rafael, *Retornos de lo vivo lejano*, Barcelona, R. M., 1977.

Paz, Octavio, *Petrificada petrificante*, Paris, Maeght, 1978.

Brossa, Joan, *U no és ningú*, Barcelona, Polígrafa, 1979.

Dupin, Jacques, *Massicciata*, Milan, All'Insegna del Pece d'Oro, 1980.

Guillén, Jorge, *Repertorio de Junio*, Valladolid, Carmen Durango, 1980.

Daive, Jean, *Tàpies, répliquer*, Paris, Maeght, 1981.

Ullán, José-Miguel, *Anular*, Paris, R. L. D., 1981

Gimferrer, Pere, *Aparicions*, Barcelona, Polígrafa, 1982.

Lartigue, Pierre, *Ce que je vous dis trois fois est vrai*, Marseilles, Ryôan-ji, 1982.

Vallès Rovira, Josep, *Tàpies empremta (Art, vida)*, Figueres, Art-3, 1982.

Brossa, Joan, *Pas d'amors*, Barcelona, Albert Ferrer Editor, 1983.

Dupin, Jacques, *Der Bergpfad*, Paris, Edition M, 1983.

Frénaud, André, *La nourriture du bourreau*, n. p., Thierry Bouchard et Gaston Puel, 1983.

Foix, J. V., *L'estació*, Barcelona, Carles Taché Editor, 1985.

Llull – Tàpies, comp. and intro. Pere Gimferrer, Barcelona, Carles Taché Editor, and Paris, Daniel Lelong Editeur, 1986.

Books and catalogue articles

Albee, Edward, 'Foreword', in the Tàpies exhibition catalogue, New York, Martha Jackson Gallery, 1968.

Alloway, Lawrence, 'Foreword', in the Tàpies exhibition catalogue, New York, Solomon R. Guggenheim Museum, 1962.

Althaus, Peter F., 'Neue Aspekte im Werke von Antoni Tàpies', in the Tàpies exhibition catalogue, Zurich, Galerie Maeght, 1975.

Althaus, Peter F., 'Neue Aspekte der Ikonographie im Werk von Antoni Tàpies', in the Tàpies exhibition catalogue, Bremen, Kunsthalle, 1977.

Augusti, Anna, *Tàpies: The Complete Works*, vol. 1: *1943-1960*, vol. 2: *1961-1968*, Barcelona, Polígrafa and Fondació Antoni Tàpies, 1988, 1990.

Ballo, Guido, 'Questa mostra antologica di Tàpies', in the Tàpies exhibition catalogue, Milan, Palazzo Reale, 1985.

Barrio-Garay, José Luis, 'Intention, Object and Signification in the Work of Tàpies', in the Tàpies exhibition catalogue, Buffalo, Albright-Knox Art Gallery, 1977.

Baumann, Felix Andreas, 'Tàpies', in the Tàpies exhibition catalogue, Zurich, Galerie Maeght, 1971.

Benincasa, Carmine, 'Antoni Tàpies: Il sigillo della storia – L'apocalisse dell'opera', in the Venice Biennale catalogue, 1982.

Bonet, Blai, *Tàpies*, Barcelona, Polígrafa, 1964.

Brossa, Joan, Francesc Vicens, Joaquim Gomis and Joan Prats Vallès, *Antoni Tàpies o l'escarnidor de diademes*, Barcelona, Polígrafa, 1967.

Butor, Michel, 'Veille', in the Tàpies exhibition catalogue, Saint-Paul-de-Vence, Fondation Maeght, 1976.

Calvesi, Maurizio, 'Su Tàpies', in the Venice Biennale catalogue, 1982.

Catoir, Barbara, 'Zu den Zeichnungen von Antoni Tàpies', in the Tàpies exhibition catalogue, Bremen, Kunsthalle, Baden-Baden, Kunsthalle, and Winterthur, Kunstmuseum, 1977/78.

Catoir, Barbara, *Gespräche mit Antoni Tàpies*, Munich, Prestel-Verlag, 1987. Translated into Catalan (Barcelona, Polígrafa, 1988), French (Paris, Cercle d' Art, 1988) and Spanish (Barcelona, Polígrafa, 1989).

Catoir, Barbara, 'Antoni Tàpies: Die Durchdringung des Objekts', in the Tàpies exhibition catalogue, Basle, Galerie Beyeler, 1988.

Catoir, Barbara, *Tàpies: Die achtziger Jahre – 'Versteinertes'*, Düsseldorf and Stuttgart, Cantz, 1989.

Catoir, Barbara, 'Die "Ars combinandi" des Raimundus Lullus in der Kunst von Antoni Tàpies', in *Gegenwart Ewigkeit*, exhibition catalogue, Berlin, Martin-Gropius-Bau, 1990.

Cirici, Alexandre, *Tàpies: 1954-1964*, Barcelona, Gili, 1964.

Cirici, Alexandre, *Tàpies: Testimoni del silenci*, Barcelona, Polígrafa, 1970.

Cirici, Alexandre, 'Antoni Tàpies o l'art del món no dit', in the Tàpies exhibition catalogue, Barcelona, Galeria Maeght, 1981.

Cirlot, Juan-Eduardo, *Tàpies*, Barcelona, Omega, 1960.

Cirlot, Juan-Eduardo, *Significación de la pintura de Tàpies*, Barcelona, Seix Barral, 1962.

Combalia Dexeus, Victòria, *Tàpies*, Barcelona, Polígrafa, 1984. French edn, trans. Robert Marrast, Paris, Albin Michel, 1984.

Dupin, Jacques, *Devant Tàpies*, Paris, Derrière le Miroir, 1967.

Dupin, Jacques, *Tàpies aujourd'hui: Assemblages et objets*, Paris, Derrière le Miroir, 1972.

Dupin, Jacques, *De vide et d'encre*, Paris, Derrière le Miroir, 1982.

Fernández-Braso, Miguel, *Conversaciones con Tàpies*, Madrid, Rayuela, 1981.

Franzke, Andreas, and Michael Schwarz, *Antoni Tàpies: Werk und Zeit*, Stuttgart, Gerd Hatje, 1979.

Frémon, Jean, 'Tableaux d'une exposition', in the Tàpies exhibition catalogue, Gordes, Abbaye de Sénanque, 1983.

Frémon, Jean, *Le corps immense du vide*, Paris, Repères 1983.

Galfetti, Mariuccia, *Tàpies: Obra gráfica 1947-1972*, Barcelona, Gili, 1973.

Galfetti, Mariuccia, *Tàpies: Obra gráfica 1973-1978*, Barcelona, Gili, 1980.

Gasch, Sebastià, *Tàpies*, Madrid, Dirección General de Bellas Artes, 1971.

Gatt, Giuseppe, *Antoni Tàpies*, Bologna, Cappelli, 1967.

Gimferrer, Pere, *Antoni Tàpies i l'esprit català*, Barcelona, Polígrafa, 1974. French edn, trans. Robert Marrast, Paris, Cercle d'Art, 1976.

Gimferrer, Pere, 'Tàpies: Indagacions i presències', in the Tàpies exhibition catalogue, Barcelona, Galeria Maeght, 1974.

Haftmann, Werner, 'Vorwort', in the Tàpies exhibition catalogue, Berlin, Nationalgalerie, 1974.

Hofmann, Werner, 'Intra Muros', in the Tàpies exhibition catalogue, Vienna, Museum des 20. Jahrhunderts, 1968.

Hüttinger, Eduard, 'Vorwort', in the Tàpies exhibition catalogue, Zurich, Kunsthalle, 1962.

Julián, Imma, and Antoni Tàpies, *Diálogo sobre arte, cultura y sociedad*, Barcelona, Icaria, 1977.

Lascault, Gilbert, *Courtes considérations autour de quelques œuvres d'Antoni Tàpies*, Paris, Repères, 1984.

Lassaigne, Jacques, 'Préface', in the Tàpies exhibition catalogue, Paris, Musée d'art moderne de la ville de Paris, 1973.

Linhartovà, Vera, *Tàpies*, Barcelona, Gili, 1972.

Llorens, Tomàs, 'Notes sobre la pintura de Tàpies', in the Tàpies exhibition catalogue, Barcelona, Fundació Joan Miró-CEAC, 1976.

Malet, Rosa Maria, *Els cartells de Tàpies*, Barcelona, Polígrafa, 1984.

Marín-Medina, José, *Tàpies: Meditaciones – 1976*, Madrid, Rayuela, 1976.

Merkert, Jörn, 'Die verrätselten Dinge: Zu den Skulpturen von Antoni Tàpies', in the Tàpies exhibition catalogue, Zurich, Galerie Maeght-Lelong, 1984.

Okada, Takahiko, Yoshiaki Tono and Lee U-Fan, 'Foreword', in the Tàpies exhibition catalogue, Tokyo, Seibu Museum of Art, 1976.

Penrose, Sir Roland, *Tàpies*, Barcelona, Polígrafa, 1977. French edn, trans. Robert Marrast, Paris, Galilée-Dutrou, 1977.

Permanyer, Lluís, 'Tàpies según la critica', in the Tàpies exhibition catalogue, Madrid, Museo Español de Arte Contemporáneo, 1980.

Permanyer, Lluís, *Tàpies i les civilización orientals*, Barcelona, EDHASA, 1983.

Platte, Hans, 'Vorwort', in the Tàpies exhibition catalogue, Cologne, Kölnischer Kunstverein, 1968.

Pleynet, Marcelin, 'Préface', in the Tàpies exhibition catalogue, Cases-de-Pène, Fondation du Château de Jau, 1981.

Ponente, Nello, 'Tàpies', in the Tàpies exhibition catalogue, Rome, Collezionista d'Arte Contemporanea, 1971.

Raillard, Georges, *Tàpies à mots découverts*, Paris, Derrière le Miroir, 1974.

Raillard, Georges, *Tàpies*, Paris, Maeght, 1976.

Raillard, Georges, *Comme une langue à venir*, Paris, Derrière le Miroir, 1982.

Schmalenbach, Werner, *Antoni Tàpies: Zeichen und Strukturen*, Berlin, Propyläen Verlag, 1974.

Schmalenbach, Werner, *Drei Reden über Antoni Tàpies*, St Gallen, Erker-Presse, 1977.

Schmalenbach, Werner, 'Protokoll seiner Rede', in the Tàpies exhibition catalogue, Zurich, Galerie Maeght-Lelong, 1984.

Schnackenburg, Bernhard, 'Die Praxis der Kunst', in the Tàpies exhibition catalogue, Bremen, Kunsthalle, Baden-Baden, Kunsthalle, and Winterthur, Kunstmuseum, 1977/78.

Sgarbi, Vittorio, 'La notte luminosa di Antoni Tàpies', in the Venice Biennale catalogue, 1982.

Tapié, Michel, *Antoni Tàpies et l'œuvre complète*, Barcelona, Dau al Set, 1956.

Tapié, Michel, *Antoni Tàpies*, Barcelona, R. M., 1959.

Tapié, Michel, *Avec Antoni Tàpies*, Paris, Derrière le Miroir, 1967.

Tapié, Michel, *Antoni Tàpies*, Milan, Fratelli Fabbri, 1969.

Teixidor, Joan, *Antoni Tàpies: Fustes, papers, cartons i collages*, Barcelona, Sala Gaspar, 1964.

Tharrats, Joan-Josep, *Antoni Tàpies o El dau modern de Versalles*, Barcelona, Dau al Set, 1950.

Ullán, José Miguel, 'Pour ce qui a trait à Tàpies', in the Tàpies exhibition catalogue, Brussels, Museum voor Moderne Kunst, 1985.

Vallès Rovira, Josep, *Tàpies empremta (artvida)*, Madrid, Robrenyo, 1983.

Valverde, José María, 'Antoni Tàpies', in the Tàpies exhibition catalogue, Madrid, Museo Español de Arte Contemporáneo, 1980.

Volboudt, Pierre, *La matière et ses doubles*, Paris, Derrière le Miroir, 1968.

Photographic Acknowledgments

Renate Bruhn Fig. 10
F. Català-Roca, Barcelona Frontispiece, Fig. 12, 84, 96
Hans Gerber, Zurich Fig. 106
Walter Klein, Düsseldorf Fig. 31, 51
Mas Barcelona Fig. 3, 18, 19, 21–23, 25, 28, 30, 33, 36, 38, 42, 46–50,
 53, 56, 59, 61, 62, 64, 68, 70–72, 77–82, 86–88, 90–93, 99–101, 105
J. Moren p. 68
L. Pomès, Barcelona Fig. 103
Hans Spinner, Grasse Fig. 39, 95, 107, 108
Peter Stepan, Munich Fig. 34